IMAGES
of America

WOODLAKE

IMAGES
of America

WOODLAKE

Marsha Ingrao

ARCADIA
PUBLISHING

Printed in the United States of America

Library of Congress Control Number: 2014952616

For all general information, please contact Arcadia Publishing:
Telephone 843-853-2070
Fax 843-853-0044
E-mail sales@arcadiapublishing.com
For customer service and orders:
Toll-Free 1-888-313-2665

Visit us on the Internet at www.arcadiapublishing.com

*To Gary and Becky Davis and Roy Lee and Donna Davis, whose family
first settled in the area and has remained through the generations*

CONTENTS

ACKNOWLEDGMENTS

Author of *Within the Magic Circle* Grace Pogue iconized Woodlake Valley as "the golden valley within the magic circle." Although Woodlake currently lacks a local historical society, community members are not without an interest in Woodlake's heritage.

I am honored that Ginny Rasmussen at Arcadia Publishing asked me to write Woodlake's story. Individuals donated most of the documents and images for this publication. Referrals for contributors rolled in throughout the writing period, starting with Gary Davis, and ending with Eunice Atherton. The Kiwanis of Woodlake quarterly magazine, *What's Happening in the Foothills*, advertised this project at no charge. Without these wonderful people, too many to name, this project would not have been possible.

This book does not document every event that shaped Woodlake. Feeling the passion and love that people of Woodlake from all over the globe have for their hometown humbles me. I apologize for the many stories and pictures omitted in this brief edition. I hope I captured a small portion of the fun and pride Woodlakers displayed for their town and neighbors.

I thank the staff at city hall, Marcy Miller, Stan and Janet Livingston, Ellie Cain, Morris Bennett, Monica Pizura, Virginia McKee, Bob and Linda Hengst, Randall Childress, Laura Spalding, Sally Dudley, Sophie Britten, Keith Glentzer, Frank and Barbara Ainley, Marilyn Young, the Hijinio Reynoso family, Slim, Eva, and Rick Knutson, Richard Rasmussen, Manuel Ramon, Lupe Rippetoe, Lisa Kilburn, Chris Crumly, Humphrey Valero, Buddy Holder, Judy Vaccaro, Claude Vice, Ernie Garcia Sr. and Jr., Carl Scott, and Bill West for giving me personal interviews, photographs, news articles, and books. Robert Edmiston became not only my greatest contributor but also coresearcher and fact editor. Sally Pace and Lauri Polly cheered me on, made phone calls, and set appointments for me. Cheryl Strachan and Lisa Raney at the Tulare County Library in Visalia found newspaper articles and photographs.

Finally, I am most grateful for my husband Vince Ingrao's support and patience holding our home and life together while I scurried around the countryside with my scanner and computer meeting the people living in our town.

All of the author's profits from the sale of this book will go to the Woodlake High School Foundation.

INTRODUCTION

Songwriter F.B. Silverwood described the Woodlake Valley in the California state song, "I Love You California."

"When the snow crowned Golden Sierras
Keep their watch o'er the valleys bloom . . .
It is here nature gives of her rarest,
it is Home Sweet Home to me."

Woodlake, California, encompasses 1,440 acres of rolling valley encircled in mountains and foothills, guarded from frost and fog that assails the rest of Tulare County. Woodlake Valley, which lies just 40 minutes west of Sequoia National Park, provides some of the richest natural resources in the world. Native to Woodlake Valley was the Wukchumne subtribe of Yokuts Indians, one of the larger tribes in North America due to the abundance of natural resources. According to author Frank Latta, no full-blooded Wukchumne remain, but some tribe members married settlers and still live in the area. Varied spellings of Wukchumne exist in the text because different sources or organizations spelled the tribal name differently.

Just as staid and protective as the circle of mountains are longtime residents, descendants of the early pioneers and later immigrants who fell in love with Woodlake and wove themselves into the community tapestry. Families expressed pride in the work their ancestors shared to develop the valley: logging, ranching, growing and packing citrus, milling lumber, manufacturing cement piping, and digging wells and irrigation canals to create the infrastructure of the city and surrounding groves and ranches.

In the 1850s, soon after the Gold Rush, newcomers from around the world ventured south into a farmer's paradise, the Kaweah delta valley. A group of doctors and lawyers came from Mariposa County to establish Tulare County at the foot of the old Election Oak Tree near Visalia. Approximately 15 to 20 miles east in the foothills of the nearby Sierra Nevada, the first pioneer, Thomas H. Davis, camped overnight in the valley, found peaceable Indians, and decided to return. In 1853, he spent his savings, brought cattle up from Mexico along the old Indian trail, now California Highway 99, and settled in the Woodlake Valley. As more settlers arrived, they surveyed the land, built houses, and focused on growing crops and raising cattle. Six pioneer families established a makeshift neighborhood named Stringtown, which the flood of 1867 destroyed. Undeterred, they moved uphill, rebuilt their homes, and bonded the community against disaster. Throughout ensuing years, attracted to the natural beauty and prosperous agriculture, others came from around the world and found their niche. Their children grew up in the valley, married, had children, and remained, protecting and developing in the land they love.

In 1907, Los Angeles–area investor Gilbert Stevenson purchased 1,500 acres to grow citrus. A decade later, his Sentinel Butte Ranch held the record as the largest individually owned orange

ranch in the world and shipped 149 train cars of citrus. By the fall of 1910, Gilbert Stevenson took an option on another 13,000 acres and began planning and building his dream, the town of Woodlake, starting with the Brick Block, a two-story business building, at the entrance to downtown. He envisioned a tourist town, brick buildings lining the streets accentuating its natural beauty along Bravo Lake with the Sierra Nevada as a backdrop. Many of the residents today descend from the friends and colleagues of Gilbert Stevenson who bought into his dream and moved to Woodlake to raise their families. They joined the pioneer community pillars.

Gilbert Stevenson remained in Whittier, California, to watch over his real estate and insurance interests there. He hired Henry McCracken to manage Sentinel Butte Ranch. Gilbert Stevenson lost his wealth during the Great Depression and died penniless and alone in 1938. In 1932, however, he deeded some of his property to Henry McCracken's son Courtney. Though Courtney McCracken never married, he continued Gilbert Stevenson's legacy through his own philanthropic generosity.

The enormous need for labor to plant and harvest vast acreages brought in many migrant workers. Many of them fell in love with the area and settled down. With a population of 1,140, predominately temporarily employed persons earning $500 to $700 per year, Woodlake struggled to become incorporated in 1939. Spearheaded by grocery owner and community activist A.P. Haury, Woodlake finally became Tulare County's seventh incorporated town in 1941. How Woodlake continued to grow through two world wars, the Great Depression, and other natural calamities and government resolutions puzzled *Visalia Times Delta* writer Sherwood Hough in 1948 and remains a well-kept secret.

At the beginning of economic recovery in the mid-1950s, the population in Woodlake declined slightly. Following the flood of the century in 1955, the town of Woodlake needed a facelift. The Brick Block decayed, was demolished in 1961, and was replaced by other ventures, including a gas station, a business that was not necessary in 1911. Enterprises and organizations changed hands as the town fathers and their sons and daughters retired, passed on, or changed occupations, and new residents arrived. The optimism of rebuilding, industrial and tourism potential, and a stable agricultural base continued. This book covers only into the 1980s. Woodlake sprang back from fires, floods, changing faces, and crushed dreams and still retained the small-town charm of a Western Mayberry.

The bones of Gilbert Stevenson's town remain much as they were 100 years ago. Bravo Lake still dominates the 2.25 square miles of city limits but is invisible from the street due to the levees he erected when he dredged the lake to make it deeper. Some of the original homes still stand in their places on Lakeview and Pepper Streets. Woodlake Hardware anticipates celebrating 100 years in 2017, with Morris Bennett and his children still at the helm.

Agriculture, the industry that brought many to riches or ruin in generations past, although still held prisoner by droughts, floods, and water-rights issues, remains the bulk of Woodlake's economy in 2015. Vast acreages, no longer plowed by horses, turned agriculture into agribusiness. The Western-style town that served the ranchers attracted businesses, transportation, and new families and grew slowly from 300 in 1914 to 7,389 in 2015. The Woodlake spirit lives on.

One

VALLEY WITHIN
THE MAGIC CIRCLE

Before 1853, large numbers of the Yokuts tribe, specifically the Wukchumne subtribe, resided peacefully in the Kaweah delta, moving from river to river and grinding acorns in the boulders. There is little attempt to tell their story here. Frank Latta documents their lifestyle in *Handbook of the Yokuts Indians* and *Tailholt Tales*. There are those today who keep the traditions and native language alive. However, a story remains to be told of the arrival of hardworking farmers, ranchers, and farm workers who came with their families between the 1850s and early 1900s and started the biggest agricultural industry in the world.

Like the Yokuts before them, settlers lived off the abundant natural resources available in the Woodlake Valley, first raising cattle and logging the rich forests in the nearby Sierra Nevada. Pioneers bought large properties and worked the land with hand- and horse-drawn implements. Beyond starting a school and a church, early settlers did not need a town to survive. Self-sufficient, these pioneers survived in the extreme weather conditions of flooding and droughts and recorded summer temperatures of 115 to 120 degrees before refrigeration. They marketed their products and bought supplies in Visalia, a two-hour horse ride away.

Usually, like-minded children of the pioneers loved Woodlake Valley, married the children of the other pioneers, and settled down to make their own way within the circle of mountain peaks and foothills. During the second generation, many ranchers began planting citrus and olive orchards and grape vineyards and raising large numbers of hogs and turkeys. Farming changed the face of the landscape primarily through the hundreds of miles of irrigation ditches needed to bring water to the semiarid land.

Using her knowledge of the second generation, teacher-writer Grace Pogue wrote a column for the *Woodlake Echo* dubbed the Golden Years, a series of articles about the families that arrived in the valley from 1853 to 1900. Chapter 1 of this book touches on Grace Pogue's *Within the Magic Circle* through the snapshots taken during those years before the dream of a town named Woodlake began.

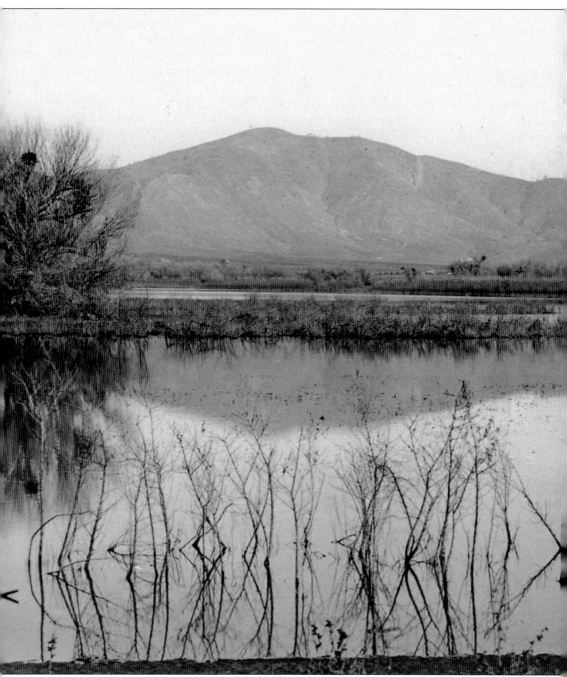

Fed by the Kaweah River, the dominant lake in Woodlake Valley ebbed and flowed. In years of drought it was swampy. In flood years such as 1862, the first recorded flood, Woodlake filled to overflowing. Yet the large lake in Woodlake is not named Woodlake. Early settlers Swamp John and Thomas Fowler squabbled constantly. Gathering the pair at the lake's edge, Thomas

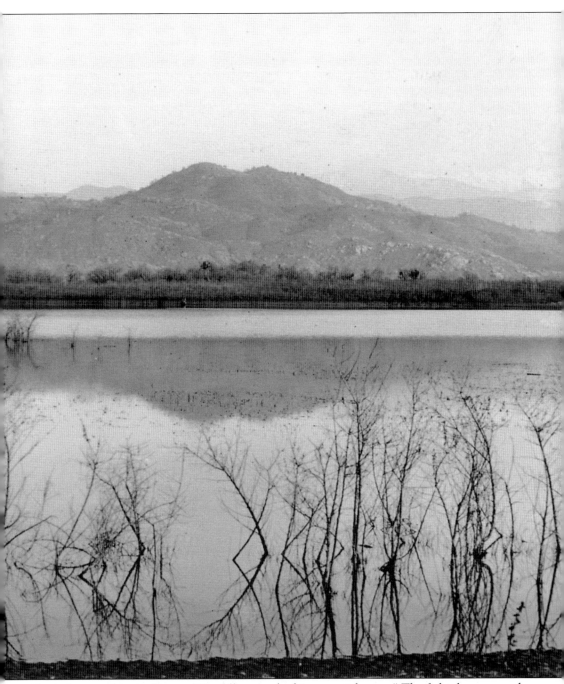

Davis drew out his six-shooter. "You fellows settle this scrap right now." The fight drew a crowd of Indians, and Thomas Fowler won the fight. Onlookers shouted "Bravo! Bravo!" That day, the lake took its permanent name and became Bravo Lake. (Courtesy of Marcy Miller.)

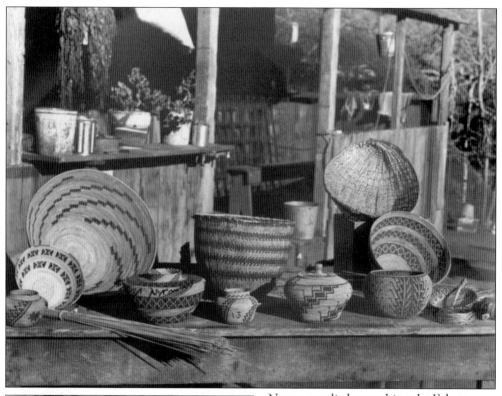

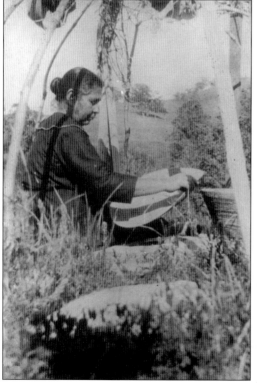

Nature supplied everything the Yokuts needed. They made baskets from swamp grasses and tules. They used clay to create pottery and wove their clothing from milkweed. For several decades, they resided side-by-side with the American pioneers. Mary Pohot made baskets near her Woodlake home. (Courtesy of the Tulare County Library.)

Mary Pohot's hut protected her from 110-degree summers. Nancy Crookshanks wrote, "The old Indian . . . said to Father, 'long time ago heap deer, heap antelope . . . big tall grass everywhere, lots everything— lots of Indians—white man he come—game he all go—no much grass—pretty soon Indians all gone. What for Jim Pogue?'" (Courtesy of the Tulare County Library.)

No story of Woodlake would be complete without a mention of Jonathan Blair, Woodlake's first pastor. Captain of a wagon train, he brought most of the first settlers to the Woodlake Valley and organized the Cumberland Presbyterian Church in 1866. He served the church without a salary until he died 20 years later. The church still stands on what used to be Blair property. (Courtesy of Marcy Miller.)

In the year Jonathan Blair died, logging of the big trees started in Converse Basin past Elderwood, marking the terminus of Millwood Road. The work was honest, often done by Woodlake Valley residents, although ramifications of destroying 2,500-year-old forests went unquestioned at the time. Teams of oxen struggled to pull parts of the trees out of the forest. Sometimes logs would mow down the oxen. (Courtesy of Slim Knutson.)

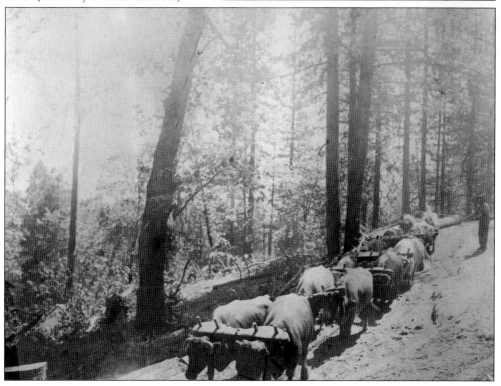

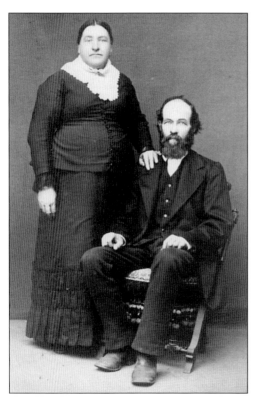

Everyone in the first settlement in Woodlake, called Stringtown, loved William and Margaret Brotherton, who moved to the east bank of Bravo Lake in 1875. They surrounded the front of their home with lilacs, blue flags, and a yellow rose bush from Tennessee, while chickens inhabited the back. Professor Dean, followed by Edward Homer, who taught in Antelope School in 1895 and 1896, roomed with the Brothertons. (Courtesy of Robert Edmiston.)

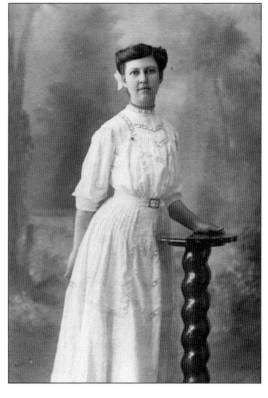

In the Woodlake area, pioneers like Grace Pogue, born in 1887, had firsthand knowledge of Native American life. She is pictured here at graduation. In *Within the Magic Circle*, Pogue wrote, "The Indian is not an improvident person. Food was never wasted." She also wrote *The Swift Seasons* and a children's book. (Courtesy of Marcy Miller.)

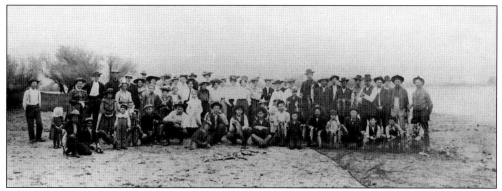

White settlers worked hard raising cattle and growing alfalfa. In the early 1850s, pioneers hauled in supplies by ox team from Stockton. Eggs cost $1 each. By the 1880s, farmers provided more than their own needs, and agricultural endeavors attracted new settlers. In their leisure time, farmers and ranchers enjoyed fishing derbies and family picnics at Bravo Lake. (Courtesy of Marcy Miller.)

Some valley settlers owned summer homes. This homestead property in the mountains, built by F.G. Hengst in 1890, included surrounding adobe outbuildings. William Hengst was the first child born there in 1891. He owned the land around 1915 and sold it to his brother Alfred, who owned an adjoining piece of property to the north. William Hengst died at the age of 103. (Courtesy of the Hengst family.)

Hunting was a way of life for Abe Dinkins, pictured here around 1910. Deer could be dangerous. Dinkins's son-in-law Harold Hengst was working in the hog barns while his wife, Wilma Dinkins Hengst, gathered laundry. He happened to check on her and found her clinging to a deer's rack to avoid being shredded by the animal's sharp hooves. He chased the deer away, saving her life. (Courtesy of the Hengst family.)

Hog wallows covered much of the Woodlake Valley. In an 1877 article, Alfred R. Wallace observed that the "areas covered by hog wallows have the unique attributes of being treeless and having a 'moveable' surface soil covering a 'less moveable one' below." These did not pose a problem for grazing cattle, but alfalfa and fruit growers flattened them for irrigation purposes. (Courtesy of the Tulare County Library.)

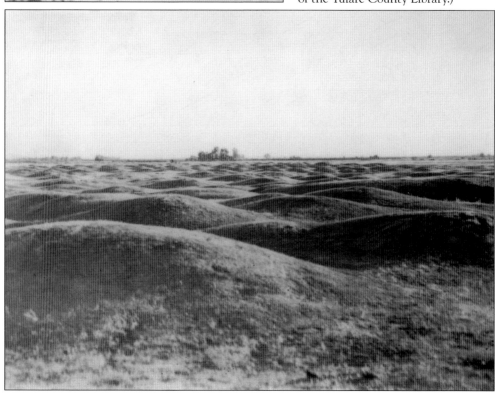

Pioneers Tom Davis, William Brotherton, and Jonathan Blair plowed their fields and raised hay and grain for cattle. William Brotherton specialized in turkey farming for 18 years. He marketed 500 to 600 turkeys annually while Margaret Brotherton raised hens. Dusty air and sizzling temperatures sent some wives off to the coast or mountain cabins for the summer. (Courtesy of the Tulare County Library.)

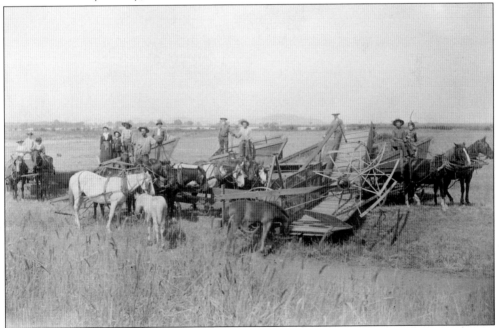

Valley settlers worked together to harvest grain in 1880. Identified from left to right are Lucinda Moffett Ragle and her two daughters, Margaret Ann and Mary Alice Ragle; Susan Blair and her brother Elmer Brotherton; James Albert Ragle; James Henry Blair; and Margaret Brotherton; the rest are unidentified. Bravo Lake stretches just below the horizon. (Courtesy of Marcy Miller.)

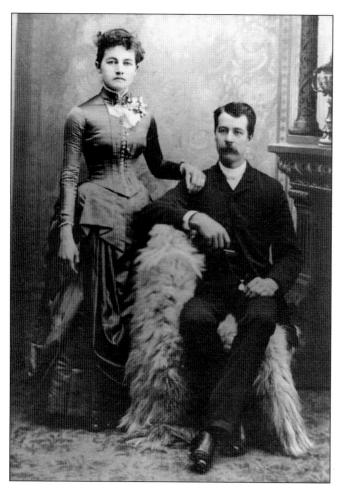

By 1863, several families from the Blair-Moffett wagon train led by Rev. Jonathan Blair moved from Red Bluff. James Blair, Reverend Blair's only son, veered from raising cattle to growing fruit. Two years after his father passed, the wedding photograph of James Blair and Susan Brotherton, taken on November 15, 1888, indicates that living in the Woodlake Valley brought financial success to these hardworking families. (Courtesy of Marcy Miller.)

Early postcards sometimes came from professional or family photographs. Lloyd Photo's black-and-white postcards depict orange groves planted on a hillside in the Naranjo area on a road going east toward Three Rivers. Primarily two varieties of oranges, valencia and navels, grew in the Woodlake Valley the 1800s. (Courtesy of Marcy Miller.)

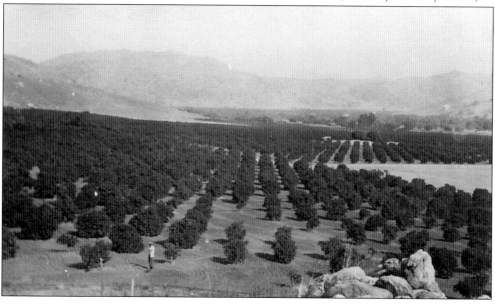

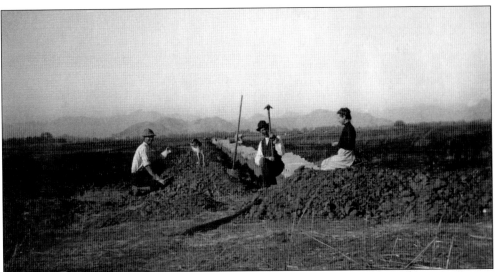

Disagreements over water, or riparian, rights plagued the settlers. The major source of water came from irrigation ditches, which farmers dug by hand. From 1872 to 1877, the Wutchumna Ditch Co. dug the Wutchumna Ditch and gained control of most of the water in Bravo Lake. Pictured here are Wendell Crumly, his wife, Mary Celia Kirkpatrick Crumly, and their oldest son, Charles L. Crumly. (Courtesy of Chris Crumly.)

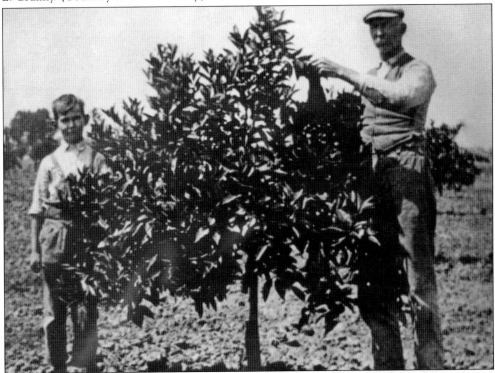

Many settlers came north from Los Angeles and found that within the magic circle of mountains surrounding the Woodlake Valley, fruit did not freeze as easily in the winter. Hal (left) and Wendell Crumly proudly display their largest tree near Elderwood around 1911. Wendell Crumly also served as a municipal judge years later in Woodlake. (Courtesy of Chris Crumly.)

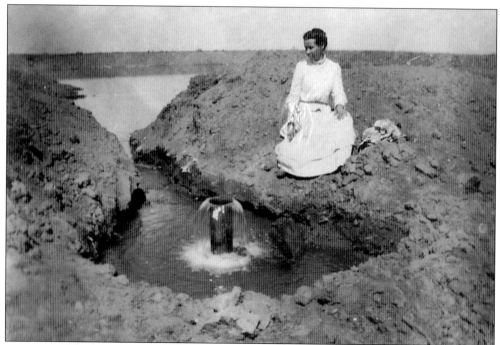

The Crumlys drilled artesian wells in low areas. An artesian aquifer occurs when water running underground is confined between impermeable rocks. When the water table is higher on either side of the well, water flows naturally to the surface through a pipe inserted into the flowing groundwater. (Courtesy of Chris Crumly.)

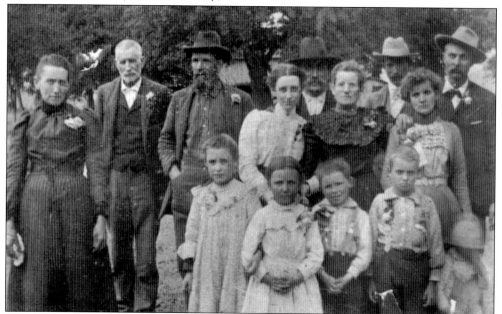

Employed by J.D. Waugh in the 1880s, Jake Bierer achieved fame as a water witch and well borer. This 1900 photograph of his family was taken at their Elderwood place, which burned in 1908. Jake stands on the top right with his wife, Janie, in the row below him, and son Ross in the first row. (Courtesy of Robert Edmiston.)

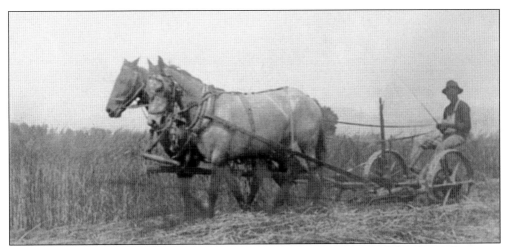

Communities in the Woodlake Valley grew steadily from the 1850s to the 1900s without any official town. Jonathan Blair owned both sides of Bravo Lake, which would later become the townsite. By the 1860s, the Colvins, Bacons, Barringtons, Fudges, and Reynolds joined the six former Stringtown residents. Pictured here in 1900, Dillard Lewis harvests his crop using a horse-drawn implement. (Courtesy of the Tulare County Library.)

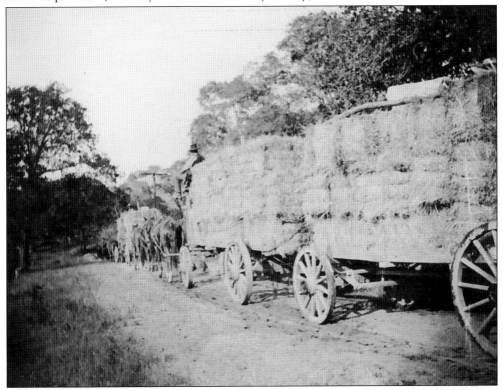

Before farmers started growing citrus in the 1880s, settlers raised wheat and livestock. Early on, wheat was sown by hand and harvested with a sickle. As methods improved, pioneers planted larger acreages that needed labor to harvest. Labor came cheap in pioneer days. Men worked from sun up to sundown for $1 a day in the winter and $1.50 a day in the summer. (Courtesy of the Hengst family.)

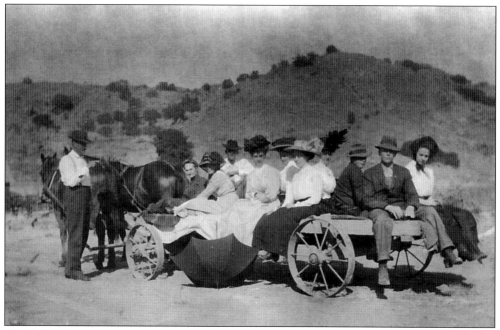

Traveling was not easy in the 1800s. Summer heat into the 100s dried the semiarid soil, turning it into silt easily lifted by dust devils. Parasols were a woman's only protection from the intense heat. Nancy Pogue Crookshanks described a wagon trip in her 1929 memoirs, remarking, "No wonder I had sore eyes . . . the dust or wind or sun had its effect." (Courtesy of the Hengst family.)

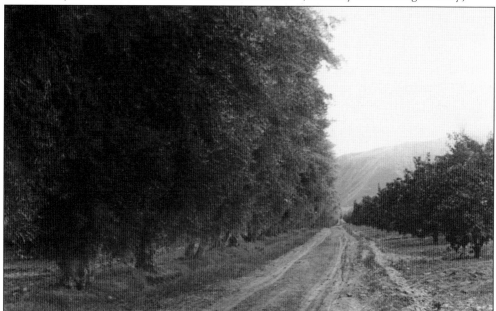

When Leah Miller Davis planted Woodlake's first orange seedlings in 1879, her husband brought them from Ivanhoe, California, then known as Klink, with a wagon and six horses. By 1905, the citrus industry had taken hold as a major crop in Tulare County, California. This Woodlake access road divides an olive grove on the left from the citrus on the right. (Courtesy of Tulare County Library.)

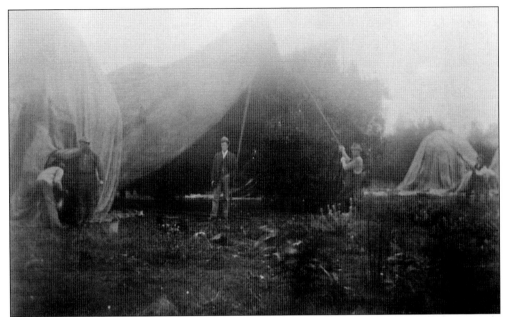

This labor-intensive fumigation procedure of tenting trees used hydrocyanic acid (HCN) to control scale with great effectiveness and originated in California in 1886. A pot placed under the tree held three parts water, one part sulfuric acid, and one part potassium cyanide, which produced an instantaneous gas. No one considered the harmful effects of the gas on themselves, their horses, or the roosting chickens in the trees, which succumbed. (Courtesy of Keith Glentzer.)

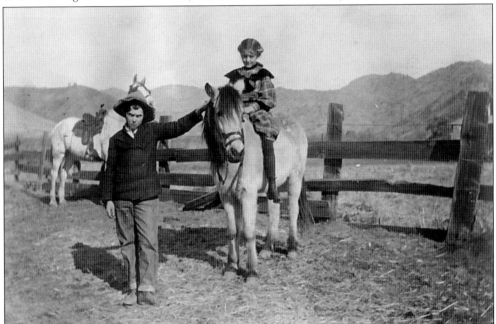

All pioneer children rode horses in the country. Spring wagons, surreys, and buggies were rarely used. According to Nancy Crookshanks, "For a lady to be seen riding astride, would have been a disgrace forever. Little girls rode sideways as soon as they possibly could." Thomas Houston Davis's children Girard and Virginia Davis pose near their home in 1907. (Courtesy of Robert Edmiston.)

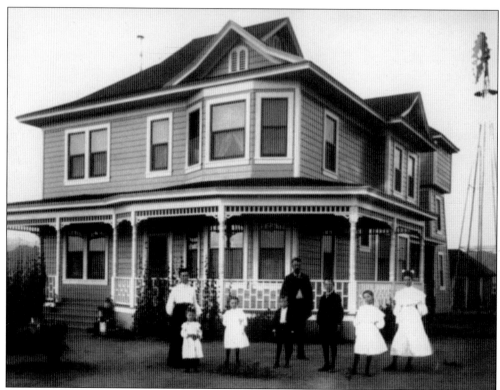

Mount Whitney Power Company delivered electricity to the valley in 1903. In 1904, James Blair moved his family to this 10-room home on Road 204 in Elderwood and installed the first party lines with the Davis and Brotherton families on the Visalia Phone Exchange. A windmill filled the 2,000-gallon water tank, which stored water for household use. (Courtesy of Woodlake City Hall.)

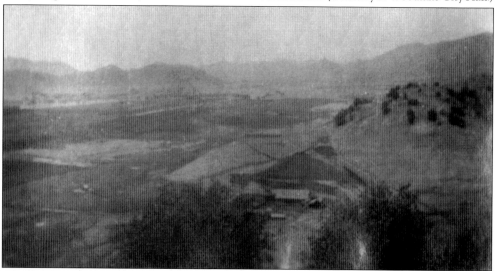

John Wesley Brown and J.D. Waugh purchased separate properties around Sentinel Butte in the 1870s. J.D. Waugh hired James Bierer to plant figs. Gilbert Stevenson, a millionaire from Los Angeles, came to Woodlake Valley in 1907. He bought the two ranches—at 1,500 acres, the largest individually owned orange ranch in the world. (Courtesy of Chris Crumly.)

As a lad, Courtney McCracken learned how to work smart as well as hard. In addition to management of Sentinel Butte Ranch for Gilbert Stevenson, he ran the packinghouse for Fred Harding. Known in Woodlake as an eccentric millionaire, he served his country and community well. He served as a California delegate to the Democratic National Convention in 1940. (Courtesy of Robert Edmiston.)

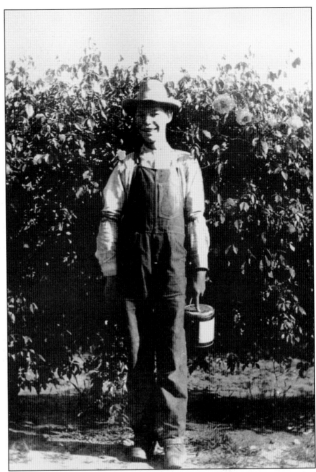

Retired Illinois senator Fred Harding vacationed in Pasadena, California, and learned about a frost-free area in the Central Valley to grow citrus. He moved with his wife, Lucy Nye Harding, to the Naranjo area, east of what would become Woodlake. Pictured here in 1904, Wicky-Up Ranch, named for the Yokuts' word for shelter, sits amid Harding's orange groves. (Courtesy of Monica Pizura.)

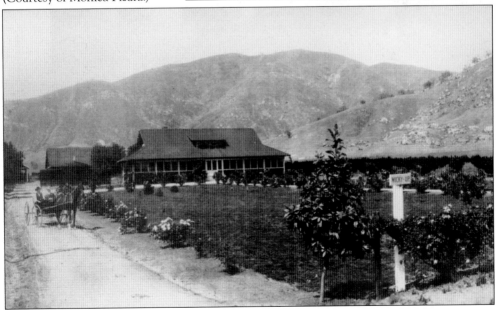

Fred Harding and Harry Brown named the community two miles east of Bravo Lake Naranjo. In 1898, Harry Brown built the Naranjo store, which existed under the following owners until 1918: the Diffenbaughs, A.R. Lahann, Elmer Brotherton, Harry Hein, and Lewis Petrea. From their screened-in porch, Fred and Lucy Harding watched activities at the two-story store and living quarters; a post office was added in 1902. (Courtesy of Monica Pizura.)

Fred Harding willed his property to his niece. She and her husband, Forest Lancashire, and their daughter moved from Texas to manage the property. Justine Lancashire (middle) attended Naranjo School for one year before going to Catholic boarding school until her last year of high school at Woodlake High School. She enjoyed summers at the ranch with, from left to right, Mary, Helen, and Charles Hein and Virginia Gaynor. (Courtesy of Monica Pizura.)

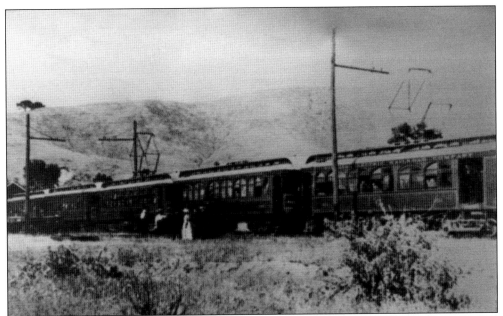

Proliferation of Woodlake's citrus and grape industries indicated a need for reliable transportation to market perishable products. Visalia Railroad Company incorporated in 1874, leasing the lines to Southern Pacific in 1899. Although Southern Pacific was not popular in the early 1900s, the rail lines, which extended to packinghouses, eliminated the need to take fruit to market by wagon. (Courtesy of the Tulare County Library.)

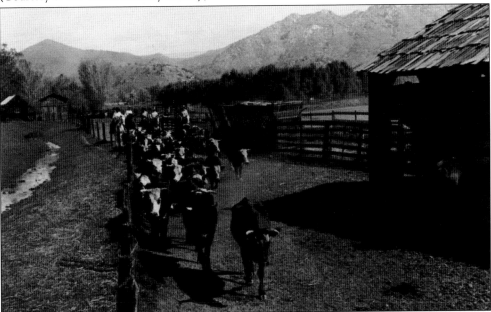

In 1871, Moses Dudley purchased a ranch north of Elderwood. His elder son, Benjamin Dudley, moved into Visalia and invested in oil and other commodities. John Dudley, the younger son, stayed on the ranch and told of the escape of famous bandit Chris Evans after the 1893 Stone Corral shootout. "He left a bloody handprint on the gate. No one ever turned him in to authorities." (Courtesy of the Tulare County Library.)

James F. Mitchell, originally from Missouri, moved often, doing a variety of work, including railroad and road construction. Moving to Elderwood from Lemon Cove, James and Ottie Mitchell built their home in 1909 with all the conveniences, including a telephone. In 1912, neighbor Abe Dinkins called for a doctor from Visalia from Mitchell's telephone when his daughter Wilma was born. (Courtesy of Janet Livingston.)

Even though they were the only family in Elderwood to own a car, Mitchell rode in style behind Stanley, proudly taking his master on his errands, possibly to the Rodgers Store at Millwood and Avenue 364. A leading horticulturist and one of the 10 founders of Kaweah Lemon Company in 1905, James Mitchell cared for his and several other citrus groves. (Courtesy of Janet Livingston.)

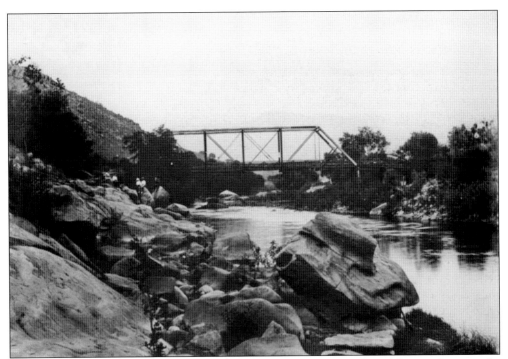

The Old Iron Bridge crossing the Kaweah River became a landmark and favorite location for a family picnic. Two construction gangs worked day and night with the aid of electric lights to complete the bridge in the fall of 1909. Workers continued to lay track through the winter. (Courtesy of Woodlake City Hall.)

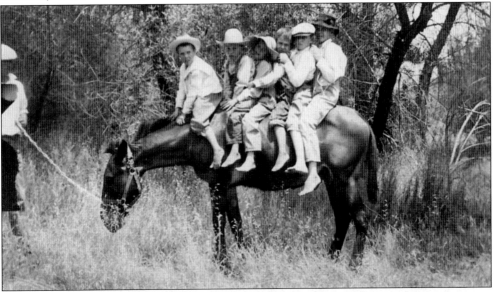

As they rode all over the prairie, the Crumly boys had no idea they would work in a grocery store owned by A.P. Haury in a town named Woodlake that did not exist. Hal Crumly, squeezed in the middle, did not know he would come back Woodlake after college to start a refrigeration business that would survive generations and enable the citrus industry to ship worldwide. (Courtesy of Chris Crumly.)

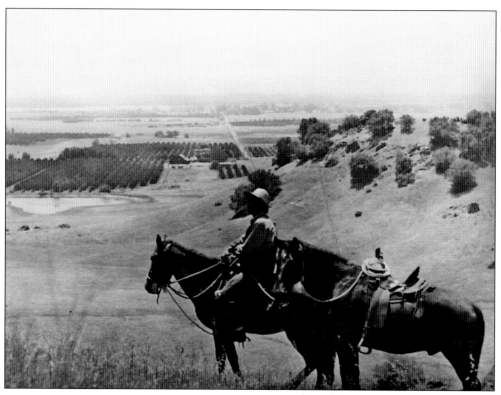

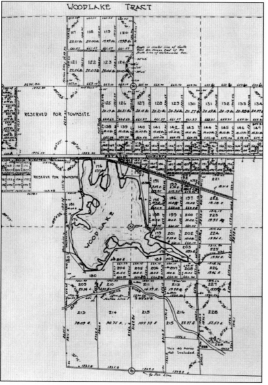

Looking down into the protected valley at the new groves of oranges, this young cowboy could picture the past—the time James Blair teased Old Blind Molly one time too many, fandangos with 500 Wukchumne gathered around. The dancers, after finishing their meal of tortillas and acorn soup, joined hands in a big circle. He probably also visualized the future work of growing oranges to ship around the world and building a modern world around himself. (Courtesy of the Hengst family.)

From the time Gilbert Stevenson, known as the "Father of Woodlake," arrived in the Woodlake Valley in 1907, he imagined building a resort town in picturesque Woodlake Valley. First he proved that ranching could be profitable. On Sentinel Butte Ranch, he drilled a wagon-wheel well, built a cement reservoir, and hired Henry McCracken to manage his commercial agricultural operation. Then he started his dream. (Courtesy of the Tulare County Library.)

Two

MILLIONAIRE BUILDS DREAM RESORT TOWN

Gilbert Stevenson dreamed Woodlake into existence, and on May 24, 1912, the Woodlake Townsite Company brought his dream to fruition. As secretary and general manager of Western Mutual Life Association, Stevenson's experience prepared him to make big plans for Woodlake. In 1899, he had moved his insurance business from South Dakota to California, where he bought a 10-acre homesite on the corner of Hollywood Boulevard and Vine Street. As his first land-development project, he subdivided a piece of property into hundreds of lots in Wilmington, California, following the construction of the San Pedro Breakwater. He founded the town of Waukena on 4,000 acres. In 1907, he purchased Sentinel Butte Ranch and built a well, concrete reservoir, and well-equipped concrete packinghouse. Realtor Steve Webb joined the Woodlake dream 1909. Woodlake neared reality.

The Woodlake Townsite Company promoted Woodlake as "The Fastest Growing Town in Central California." In the first year, Gilbert Stevenson funded three downtown buildings, wells, water mains, sewer lines, and 10,000 ornamental trees and shrubs, which lined the streets laid out by John Pogue. Thomas Crawford paved curbs and sidewalks, and crews built and occupied comfortable bungalows. By 1915, most of the 13,000 acres had been sold, hundreds of fire-proof homes built, and individually owned citrus groves developed.

The Brick Block housed business such as Frank Mixter and Arthur Schelling's Drug Store, Chandler's Restaurant, W.J. Ott's Hardware, and Frank Main's Pool Hall and Barbershop. The library opened in the drugstore, as did the post office. First National Bank opened, and Woodlake native James Blair became its first and only president, with W.S. Bean as cashier and manager until it closed in 1932. By 1915, it had $60,000 in individual deposits.

In addition to the Brick Block foundational building of downtown, Woodlake had a weekly newspaper, two schools, 200 pupils, a mile of electric-light lines, five miles of sidewalks and curbs, and a $40,000 hotel. Next, the men and women of action raised $9,000 to build their own telephone exchange, separate from the Visalia line. Woodlake boomed.

Gilbert Stevenson signed papers with Tulare County Board of Supervisors on October 3, 1911. Bringing skilled labor and merchants from Los Angeles, the millionaire built the first downtown building. The Brick Block marked the entrance to Woodlake on the northeast corner of Valencia and

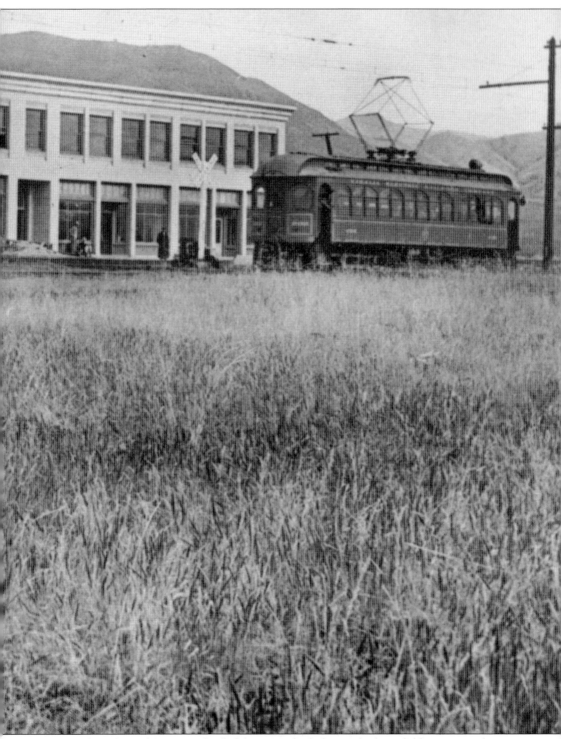

Naranjo Boulevards. Within a year, the fledgling town had a hospital, a branch library, a merchants' association, city waterworks, and two doctors. (Courtesy of the Tulare County Library.)

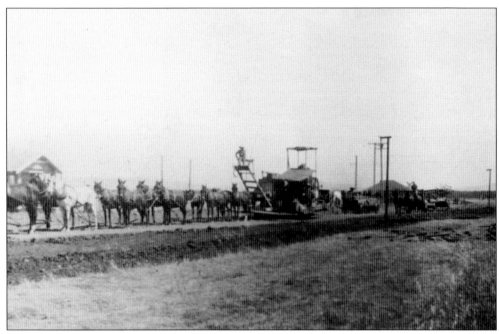

In the early years, investors and residents quickly built town infrastructure along the main streets in Woodlake. John Pogue directed workers to level the streets while Thomas Crawford laid cement curbs and sidewalks. Once graded, the streets were lined with 10,000 ornamental trees and shrubs. Gilbert Stevenson filed plans for the first two-story brick office building. (Courtesy of Marcy Miller.)

James Barton, J.W. Fewell, and Adolf Sweet helped fuel the Woodlake frenzy in 1907 when they purchased the tract of land three miles north of Bravo Lake. They subdivided the development they named Elderwood. John P. Day, brother of D.B. Day, purchased property there and built his home and a rural post office on Millwood Drive. (Courtesy of Marcy Miller.)

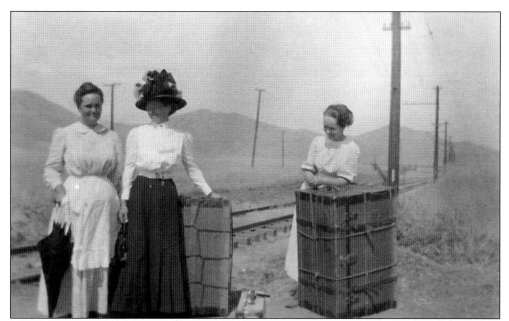

Transportation in and out of Woodlake on the Visalia Electric was simple, though not always comfortable. From left to right, Mattie Day, Willa Towt, and Gladys Day await the train with no shelter. Companies pioneered electric trains worldwide, but Visalia Electric gained notoriety when it became the first to use alternating current. Expensive to run and maintain, trains increasingly fell into disuse as automobiles became more popular. (Courtesy of Marcy Miller.)

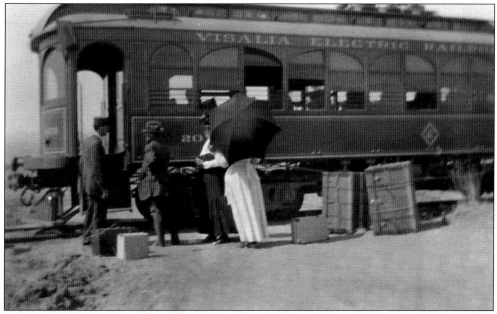

Irma Cole Loverin included the following in her memoirs from June 1911: "It was very hot —over 100 degrees. . . . No one told us that Woodlake was called 'Bravo'. . . . We rode the train ten miles further, and walked two miles to Elderwood Store where we met a Mr. McCracken. He . . . [took] us in his wagon back to Woodlake where my father [D.C. Cole] was waiting for us." (Courtesy of Marcy Miller.)

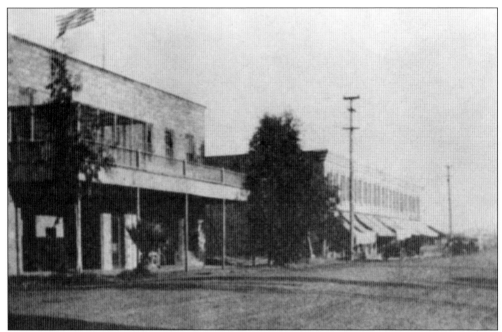

John Day realized early on that the post office was not conveniently located in Elderwood. One day after work, realtor Steve Webb and John Day loaded the equipment into a one-horse buggy and moved the post office from his home to the new townsite. This photograph of the Musson Building post office was taken in the 1930s. (Courtesy of Marcy Miller.)

Woodlake Drug Store first housed the newly located post office, and J.P. Day employed Vera Musson as his postal clerk. John Day bought a pair of swans for Bravo Lake and provided a gasoline launch on the lake for the 1913 Fourth of July celebration. Edith Day Kress took over as postmaster after J.P. Day passed. (Courtesy of Randall Childress.)

Gilbert Stevenson never moved from Los Angeles. He hired head contractor D.B. Day, who bought into the Woodlake dream. D.B. Day moved his wife and three children, Adrian, Donald, and Gladys, to Woodlake and built his home. As the first house was finished in 1911, it did not take long for the family's home at 133 North Palm Street to become the social center of the town. (Courtesy of Marcy Miller.)

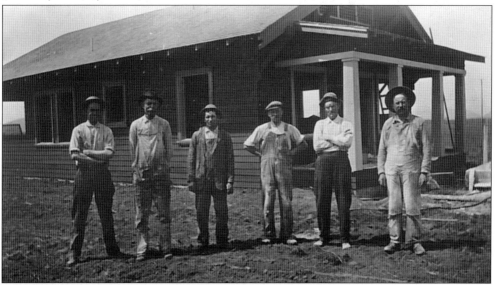

Dr. Pinkley's family lived in the new Johnston Apartments with an office upstairs in the Brick Block building. One year later, Dr. Pinkley moved to Southern California and sold his practice to Dr. J.F. Pringle from Nebraska. Soon, Dr. Pringle and his family built homes on Palm Street. Pringle's wife donated time to the Methodist church. (Courtesy of Marcy Miller.)

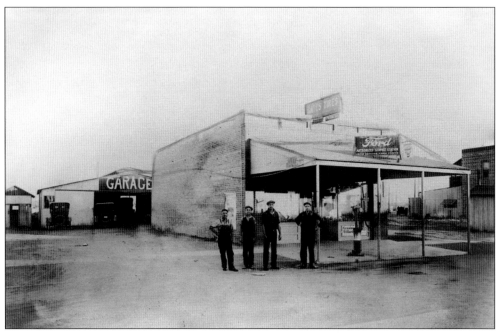

South of the tracks, W.R. Clevenger built a livery stable. Gordon Day had developed a thriving hardware business, which he sold to W.J. Ott in 1913. After that, Gordon Day devoted his time to developing his garage business and blacksmith shop at the livery stable. (Courtesy of Marcy Miller.)

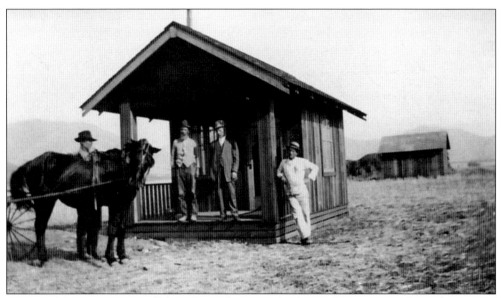

E.H. Snedeker came to Woodlake selling advertising for the *Visalia Morning Delta* and was roped into starting a newspaper. Gilbert Stevenson subsidized the *Echo*, and within a year his friend J.G. Ropes, director of a Los Angeles life insurance company, became the editor. John Ropes gave his time and counsel to everyone and published the *Echo* with no liquor or tobacco advertisements. (Courtesy of the Tulare County Library.)

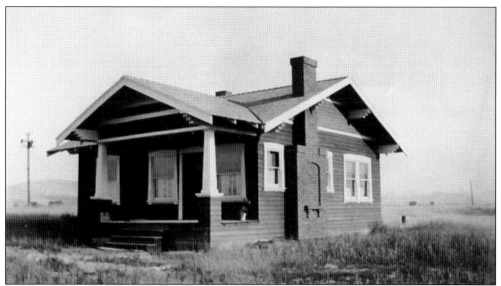

Typical of Woodlake's new citizens, Adrian Day and his new wife, Edith Blair Day, wasted no time getting established. In 1913, his father, D.B Day, built them a home at 596 West Lakeview Avenue. They moved in and got right to work, first establishing a grocery store, then later a dry-goods store in 1925. (Courtesy of Marcy Miller.)

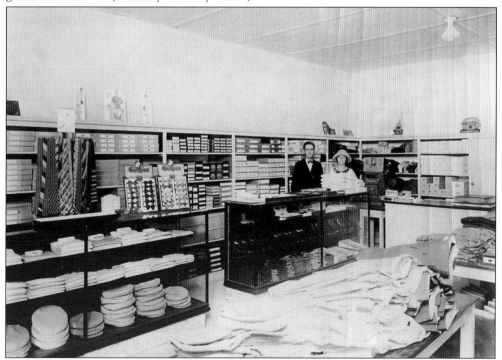

The pastor's dog Curley knew how to open the candy case and help himself to his favorite candy at the Days' store. Adrian Day's daughter Marion tattled to her mother, Edith, "Oh Mama, Papa kicked Curley," just as the pastor's wife entered the store. Grace Pogue described the subsequent atmosphere as electrifying. In their spare time, both Days enjoyed playing musical instruments. (Courtesy of Marcy Miller.)

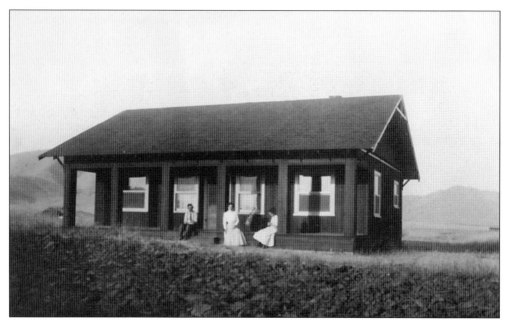

D.B. Day's head carpenter, Charles Lare, also saw the town's potential and built his home at 200 North Palm Street. All this time, Charles Lare worked steadily on the Brick Block, which would house Mills Grocery, Haury Dry Goods Store, Chandlers' Restaurant, First National Bank, Woodlake Drug Store and Post Office, Dr. Pinkley's office, and for a short time, Woodlake High School. (Courtesy of Marcy Miller.)

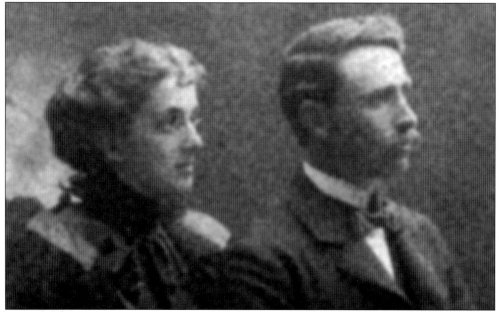

Gilbert Stevenson met D.C. Cole in Los Angeles and convinced him to move his family to Woodlake. The Coles lived in a large tent by the side of the Wutchumna Ditch while Dewitt Cole worked for D.B. Day building town buildings. At the same time, he erected the family home east of Woodlake in the Naranjo area and prepared his 40 acres for oranges. (Courtesy of Sophie Britten.)

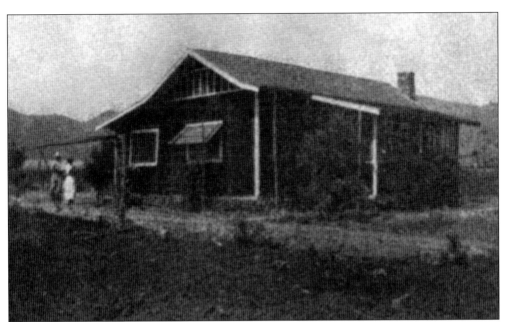

D.C. Cole finished his home in Naranjo, east of Bravo Lake, by winter, without electricity or running water. A hard freeze killed most of the trees, and he had to replant the orchard the following spring. They joined the Presbyterian church, Masons, and Eastern Star. Mabel Cole taught piano lessons. Both D.C. and Mabel De Long Cole lived on the ranch until they died. (Courtesy of Sophie Britten.)

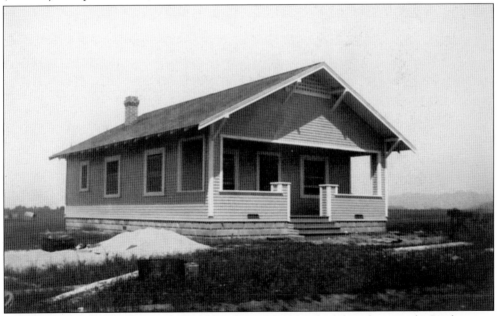

A.P. Haury built his first home at 1912 North Pepper Street, which later became the Presbyterian manse. Active not only as a merchant, he served on the First National Bank Board of Directors and as treasurer of the Merchant's Association. He also served on the high school board of trustees and in later years revived the Woodlake Chamber of Commerce as the Woodlake Service Club under his presidency. (Courtesy of Marcy Miller.)

Clement Haury, one of the Haurys' five children, plays outside before A. Haury had a chance to plant his many rose bushes. Clement Haury delivered groceries to Haury's Elderwood customers when he attended high school. Alice Mitchell warned that everyone needed to stay off the roads when Clement sped through town. (Courtesy of Marilyn Young.)

West of town, ranch houses in Dutch Colony sprang up near the native oak trees, which provided a bit of shade. Keith Glentzer remembers a home ordered from the Sears catalogue. The wood looked the same inside and out, so insulation was probably nonexistent, and the roof leaked during the winter. Eventually, new owners moved the Sears house off its raised foundation to another community. (Courtesy of Keith Glentzer.)

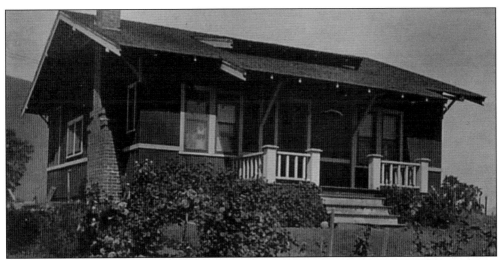

In newly established Dutch Colony, Daniel Buchmann arrived in 1915 with his wife from Kansas and built his permanent stick-built home. He planted oranges in the rocky soil. Like other Woodlake newcomers, Albert P. Haury, J.J. Wedel, and M.H. Beutler became members of the Woodlake Citrus Development Company. (Courtesy of Keith Glentzer.)

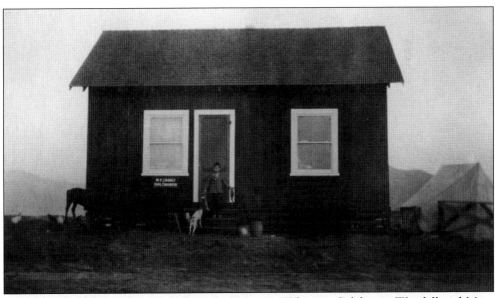

In early spring, after talking to Gilbert Stevenson in Whittier, California, Wendell and Mary Crumly purchased 20 acres north of town in the Elderwood Colony. The new town quickly discovered Wendell Crumly's surveying services. He even surveyed Woodlake's old graveyard and found only one grave slightly out of line. Their daughter Blanche Crumly graduated in the first graduating class from Woodlake High School. (Courtesy of Chris Crumly.)

43

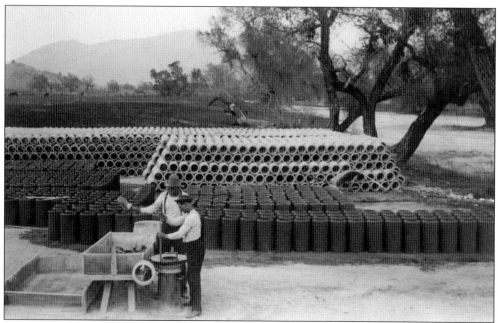

While building continued in the town of Woodlake, a few miles east of Dutch Colony, Woodlake Citrus Development Company gathered materials to build an irrigation pipeline to run across the east side base of Colvin's Mountain behind the home of Daniel Bachmann. Sand from Cottonwood Creek contained mica, which made cement leak more than pipes made from neighboring Kaweah River cement. (Courtesy of Keith Glentzer and Randall Childress.)

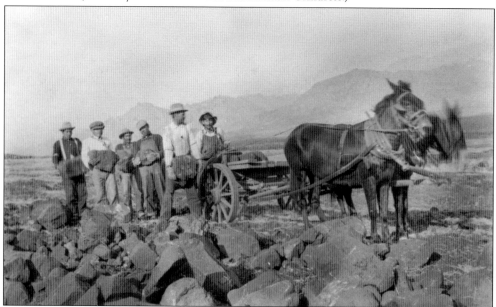

Workers removed many boulders by hand to farm the property. Even six-inch boulders weighed as much as 30 pounds. Granite boulders sank during wet years, and then when soil cracked and contracted, boulders resurfaced. Dutch Colony residents stacked boulders up, making long fences where rattlesnakes hid. During the 1955 flood, Tulare County purchased many of the boulders to aid in flood control. (Courtesy of Keith Glentzer and Randall Childress.)

Infrastructure had to be completed before the agribusiness of citrus development could begin to support Woodlake's economy. Land had to be leveled of hog wallows and large outcroppings of boulders on the mountain removed. The large irrigation pipeline ran across the base of the mountain. Wendell Crumly, a civil engineer who arrived in 1911, surveyed pipelines for irrigation systems and ranches. (Courtesy of Ken Glentzer.)

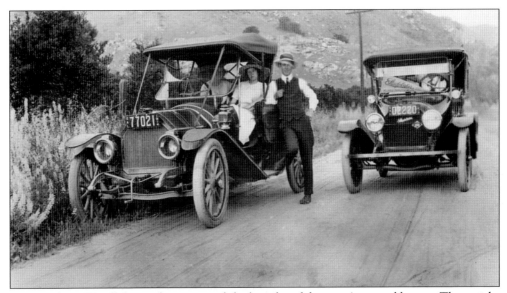

In 1915, these Woodlake residents enjoyed the benefits of the town's natural beauty. They might be stopped for a picnic along Naranjo Boulevard across from Bravo Lake. Gilbert Stevenson purchased three excursion steamers to escort tourists to the dream islands he planned to build, one for dancing, one for swimming, and one for restaurants. The steamers did not attract many tourists. (Courtesy of Marcy Miller.)

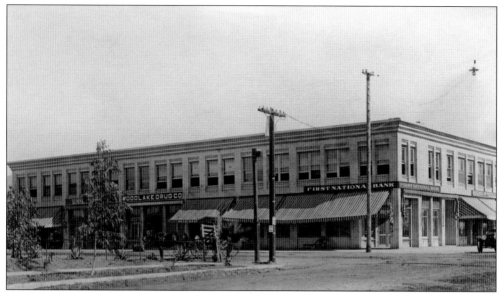

Originally, a horse-hitching rack stood on the west side of Valencia Boulevard along with a watering trough in the center of the rack. In 1914, one of the first out-of-control Woodlake automobile drivers demolished the horse trough, foreshadowing the permanent change in the mode of transportation. In the 1920s, business buildings stood on the west side of Valencia Boulevard. (Courtesy of Randall Childress.)

This 1914 panorama shows downtown on the right and individual homes on the left. Spalding Lumber on South Pepper Street nearly eclipses the Brick Block on the far right side. The town population at this time had grown to 300. W.H. Dalton wrote in the Progress Edition of the *Visalia Delta* in 1915 that the Woodlake Valley population had soared, "bringing tax revenue and new brains." (Courtesy of Marcy Miller.)

Three

WOODLAKE GROWS DURING TOUGH TIMES

In 1917, over 24 million men registered for the draft, but 65 percent of them received deferments. Classes II and III deferments temporarily kept married men, skilled industrial workers, and farmers at home. Even with deferments for farm work, California's population boom during the 1930s Dust Bowl, and the influx of workers due to the 1942 Bracero Program, agribusiness still lacked enough farm labor during war years. Manufacturing companies began experimenting with technology to remedy the labor problem. In 1935, Abe Dinkins and Abe Upp obtained a patent for a portable folding packing and weighing stand for grapes, commonly known as a weigh-pack. Better machinery and equipment made individual farmers more efficient and productive.

Oren Ruth and his friend Paul Krehbiel in Reedley bought Gordon Day's hardware store. Business boomed in spite of the Great Depression that started in 1929, and they added 20 employees in 20 years. Morris Bennett, Ed Crowley, and Alan Savage started in 1940.

In 1932, Gilbert Stevenson deeded some portion of his property to his ranch manager Courtney McCracken. The Great Depression took Gilbert Stevenson's entire estate, including $50,000 he saved for emergencies, and he was too proud to ask for help. The *Woodlake Echo* eulogized Woodlake's founder with these words:

> For whatever had motivated his boyhood or younger manhood, in his later years he learned to feel for the weaknesses of human beings and try to find a way for a more happy civilization. Thus ran the mind of this man, perhaps the truly greatest, in spite of his faults, to walk through Woodlake. In his younger days his mind was filled with making the land produce and making money selling land—in his old age he saw the inequity of human beings. . . . Let everyone who loves Woodlake pay a brief tribute to the man to who built its brick block and laid out its streets.

The town grew during the tough years and incorporated under some controversy in 1941. It did not become the resort town that Gilbert Stevenson envisioned, but agriculture, which preceded Woodlake, remained its stability.

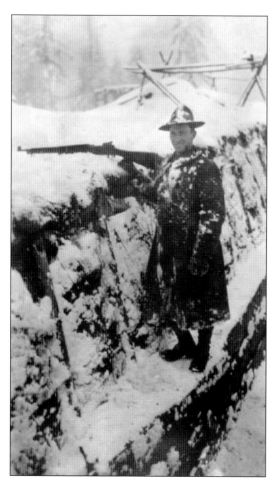

Woodlake native Roy Davis faced a different climate during his service in World War I. Woodlake residents who served in World War I included Erwin Denton, Carl Lawrence, Marcellus Brown, Chick Eberle, Will Lewis, Daniel Parcel, Abe Upp, Dan Bachmann, Jimmy Crowley, Frank Smith, Royal Hart, and Grover Kite, who never fully recovered from his injuries during the war. (Courtesy of the Tulare County Library.)

In 1919, Muz and Frank Millen began their new career in the new town of Woodlake as proprietors of the Mill Inn Café and small hotel in the Brick Block. Frank Millen ran errands and cleaned up, while Muz shopped, cooked, baked, and gave advice to those who came. The sidewalk menu invites customers to "cool down inside." (Courtesy of Ellie Cain.)

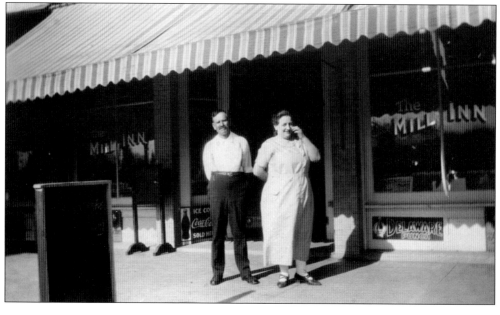

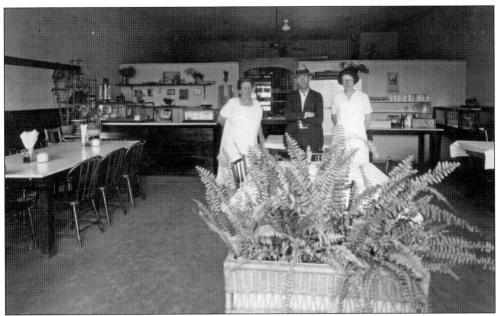

During a free moment, Muz (left) and her employees Pete Blair and Agnes Tripp pose after a busy day. The Millens lived upstairs in the hotel, along with a resident named Grover Kite. Once, 3.5-year-old grandson Buddy wandered out on the roof and sat near the edge, inches below the main electrical transformer wires. Dixie, the dog babysitter, alerted adults, and Buddy lived. (Courtesy of Ellie Cain.)

The 1931 *Sequoia* yearbook advertised Haury's store (called the "Modern Store"), Bill Merrow's Barber Shop, Joe Albo's Woodlake Bakery, Stuart Spalding's Garage, Mable Grubbs' Beauty Shop, A.R. Schelling's Drug Store, Dr. Frasier's Sequoia Hospital, Mrs. M. Rowland's Busy Bee Café, the *Woodlake Echo*, and Charles Longuevan's Shoe Store. In 1936, Bank of America opened in the Brick Block. Woodlakers enjoyed full-service shopping downtown. (Courtesy of Woodlake City Hall.)

Famous for its wildflowers, downtown Woodlake remained rural in the mid-1920s. In addition to running a thriving business and caring for their grandbaby Mary Francis Santa Maria, Frank and Muz Millen participated in the chamber of commerce and Kiwanis. Muz Millen recalled preparing meals for 50, and only 15 showed up for Kiwanis meetings. (Courtesy of Ellie Cain.)

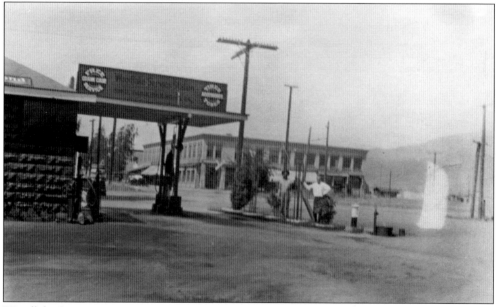

Woodlake Gas Station sat across Valencia Boulevard, running north and south, and kitty-cornered across Naranjo Boulevard, running east and west, from Mill Inn. The Visalia Electric train came right up Naranjo Boulevard and stopped by the Brick Block. Except for the Brick Musson Building, south and east of the Brick Block was still undeveloped in the 1920s. (Courtesy of Ellie Cain.)

The 1920s through the 1940s were tough times in the United States. Two world wars, the Great Depression, and the Dust Bowl left the country reeling. Conversely, agriculturally rich Woodlake prospered and grew in size. Gas rationing kept locals shopping near home. Bonnie Spalding and his wife, Billie, had a trucking and lumber company and operated the Elderwood Market, pictured in the background. (Courtesy of Laura Spalding.)

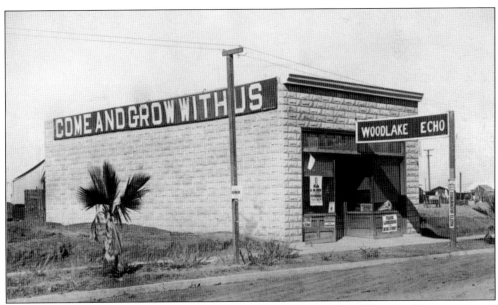

In the 1920s, the *Woodlake Echo* rented space to "the telephone office." Roy Lee Davis explained how his uncles, who worked at the *Echo*, answered the phones. Number 42W lit up. Operators answered, "Oh, Roy Davis's family has gone to the mountains. I'll patch you to Silver City." Woodlake's secrets were scarce in the early 1900s. (Courtesy of the Tulare County Library.)

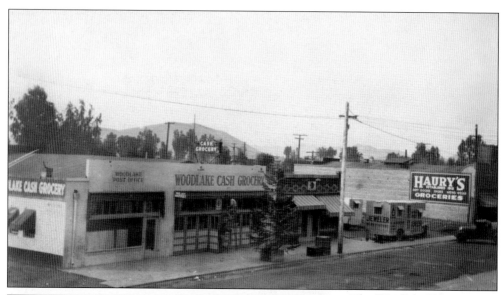

The *Woodlake Echo* squeezed between two grocery stores, Woodlake Cash and Haury's. Haury's Market advertised that it was the "Home Owned Store Where Your Dollars Do Double Duty—Benefit You and Your Community." For example, A.P. Haury, Gordon Day, Steve Web, and Frank Mains sponsored a city baseball team, which attracted folks from miles to the Sunday games near the lake. (Courtesy of Ellie Cain.)

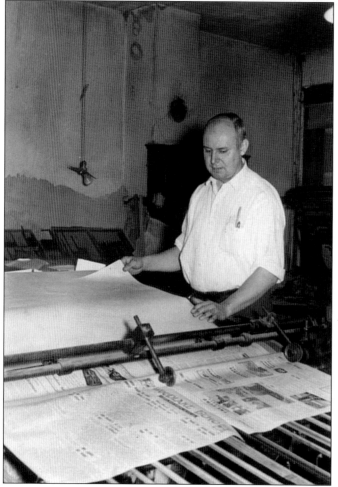

Starting at age 14, John G. Ropes worked for a print shop for $3 a week. Realtor Steve Webb sold him the *Woodlake Echo* and the building lot to house it. Ropes used the power of print to help bring Highway 65 to Woodlake, and when Ropes died in 1935, Woodlake named a street in his honor. (Courtesy of Woodlake City Hall.)

In 1931, four-year-old Buddy Santa Maria, tired of riding Grover Kite's horse, jumped off, lost his hat, broke his arm, and went to Woodlake Sequoia Hospital. Dr. Fraser set his arm while nurse Jean Keys attended. She became a lifelong friend. Dr. Fraser gave Buddy a sheepdog puppy, which he named Doc. Four years later, Drs. Clarence Wells and Max Waters opened a new hospital. (Courtesy of Ellie Cain.)

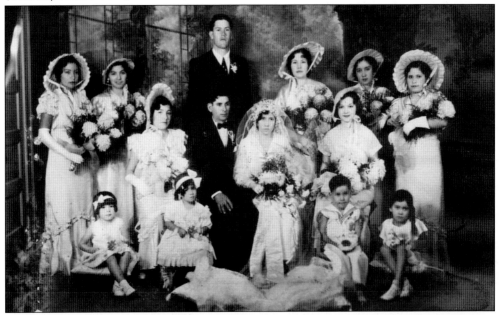

Maria Diaz and Joaquin Lupercio Rivas wed in 1934. Both came from Mexico as children to escape the Mexican Revolution. Fieldwork brought the young couple to Woodlake, where they raised their nine children. They purchased 80 acres of grapes south of town. Maria worked at the Redbanks Packinghouse, taught catechism classes, and was selected as Woodlake Woman of the Year in 1976. (Courtesy of Lupe Rippetoe.)

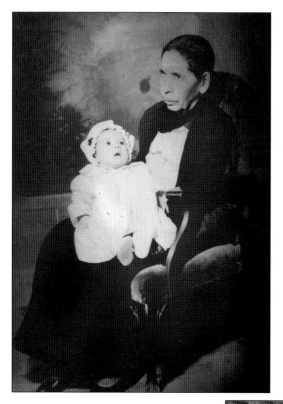

Grandmother Diaz is pictured here holding grandson Joe Rivas, who wore his 1935 baptismal gown. Grandmother Diaz never learned English and insisted that her children learn both Spanish and English so they could translate. As an adult, Maria Diaz Rivas translated constantly for schools and church. Maria Rivas also insisted that her children study hard and graduate from Woodlake High School. (Courtesy of Lupe Rippetoe.)

Four of the five Rivas girls pose in their Christmas finery: Connie stands behind Frances, and Lupe Rivas Rippetoe got to hold her baby sister Terry. Lupe Rippetoe remembers their original home with no running water or air-conditioning and the woodstove for heat. Summertime meant working in the fields, preparing food, and swimming in the St. John's River. (Courtesy of Lupe Rippetoe.)

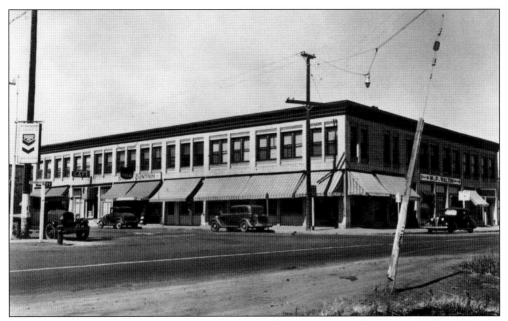

This placid scene belies the struggle that leaders had to incorporate the town in Tulare County. On October 31, 1939, the voters decided to incorporate. Judge Frank Lamberson affirmed in court that the majority of voters favored incorporation, but voting records, routinely destroyed, could not prove the validity of the vote. (Courtesy of Woodlake City Hall.)

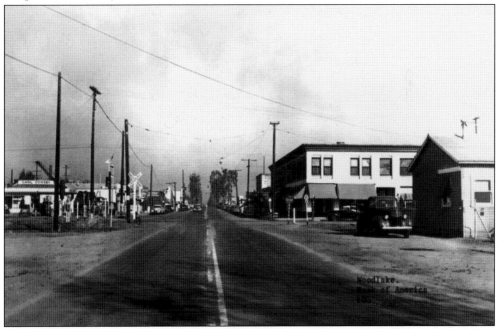

After months of litigation, the incorporation was declared null, creating a bookkeeping mess. The photograph above was taken south of Valencia and Naranjo Boulevards and shows the town, which wanted to incorporate to prevent a potential shack town just outside the city border. Farmers felt that taxes would be burdensome because the 150 men living in town making $500 to $700 per year could not carry the tax load. (Courtesy of Woodlake City Hall.)

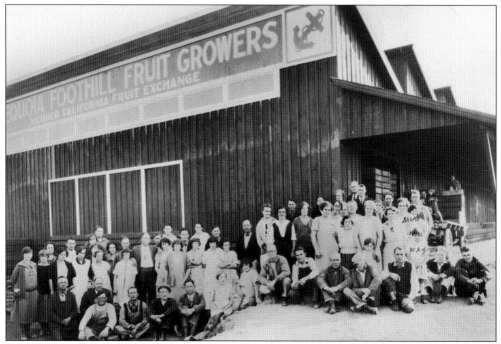

Packinghouses were early Woodlake's primary employers. On May 4, 1922, vineyardists Earl McGuire, H.C. Allen, George S. Daniels, Ralph Ainley, Phillip Wedel, Celeste and Otis McCabe, Truman Berry, Paul Bodine, and John S. Jobe formed a cooperative, Sequoia Fruit Growers, for packing and marketing their grapes. By 1925, some 29 growers had affiliated and hired George Lund to construct and manage the new packinghouse for $6 a day. (Courtesy of Marcy Miller.)

In the late 1940s, Eduardo Alva prunes grapevines, leaving a head and two renewal canes, which he tied to wire supports. The March 1991 issue of *Visalia Voice* by Mary Terstegge reported that Redbanks greenhouses jumpstarted 15 varieties of plums, 14 types of table grapes, and several varieties of peaches. (Courtesy of Manuel Roman.)

Like Ernie Garcia and this unidentified boy from Redbanks, students and adults alike played baseball after work for city teams. Redbanks, located west of town, ran the largest deciduous fruit orchard and packinghouse in Tulare County. Ernie Garcia, who moved to Woodlake in the 1930s, remembered that the students from Redbanks filled the bus to go three miles to Woodlake schools. (Courtesy of Manuel Roman.)

From left to right, Mary Garcia, Joe Costello, and Hortensia Perez stand in front of Redbanks apartment complex, where Ernie Garcia lived with his family, west of the Redbanks Packing House around the bend in the creek. In the 1940s, students often worked in the fields and served as the breadwinners for their families. They remained exempt from service in World War II unless they married. (Courtesy of Ernie Garcia.)

Elmer Wright first occupied the building that became Dead Rat Saloon at the Redbanks Corner. In the 1940s and 1950s, it was a lunch restaurant. Ernie Garcia remembered the Franco brothers Asencion, Joe, Philomen, and Jesse, pictured from left to right. Another brother, Nash Franco (not pictured), made a name for himself dancing at McKays Point and the Pentecostal Park Association of Visalia (PPAV) on Main Street in Visalia. (Courtesy of Manuel Roman.)

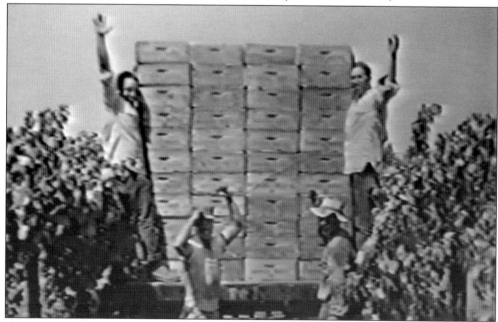

Workers in the 1950s swamped grapes, packing, tossing, catching, and stacking 26-pound wooden boxes onto the truck bed. The workers were paid piece rate by the box. Mary Anne Terstegge wrote, "Under the Arena's care, Redbanks had another hey-day. . . . In July 1955, 17 carloads of fruit per day left Redbanks." (Courtesy of Manuel Roman.)

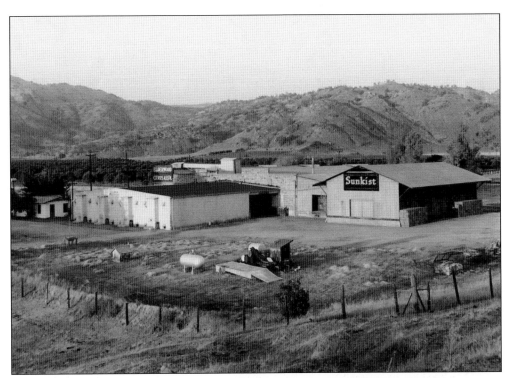

In a 2003 California Humanities interview, Alice Mitchell described life portrayed by this 1929 photograph of Elderwood Packinghouse. "We shipped our oranges, but I think that one thing that was interesting at that time and for a number of years was that the oranges were wrapped individually in tissue paper, a little orange paper and they were packed in wooden crates." (Courtesy of Janet Mitchell Livingston.)

Bryon Corbitt managed the Elderwood Packinghouse in the 1940s. According to Alice Mitchell, "They hired many local people to work in the packinghouse. I couldn't tell you what the prices were . . . but I'm sure [World War II] must have had some affect on them." Huntington Library included both Elderwood Citrus Association and Elderwood Packinghouse Company crate labels in its collection. (Courtesy of Robert Edmiston.)

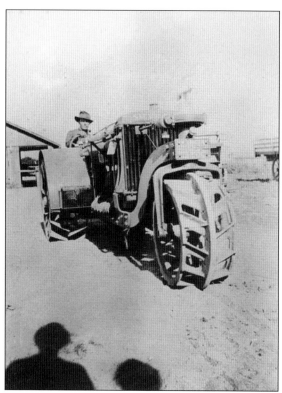

Rudolph Frey used this Sampson tractor on the ranch around 1934 in Woodlake. The Stockton- based company, named Samson Tractor Company in 1916 and the Samson Sieve-Grip Tractor Company in 1917, produced tractors from 1900 to 1923. General Motors then purchased the company and entered the market for farm tractors to compete with the Fordson Model F tractor. (Courtesy of the Tulare County Library.)

Pesticides are used to control organisms like scale that are considered to be harmful to the fruit. *The Citrus Industry, Volume 5* reported that in 1916, citrus farmers first tested liquid hydrogen chloride, which could be sprayed from a machine drawn by a horse. By 1918, this method was used exclusively, without the use of protective gear for either the humans or horses. (Courtesy of the Tulare County Library.)

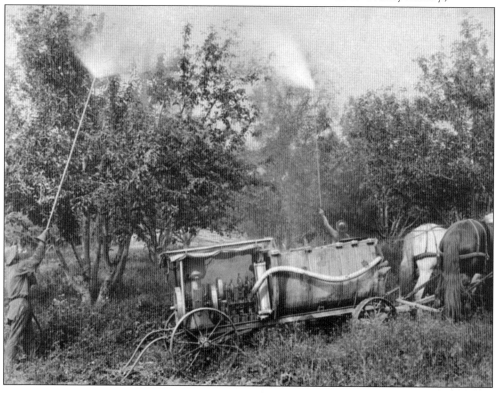

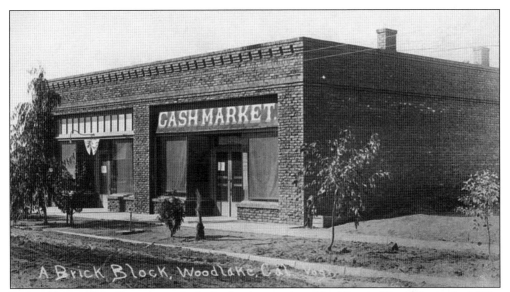

Richard Ropes, John Ropes's son, built this brick commercial building in Woodlake in the 1930s. The left side of the building housed the weekly newspaper. Gladys Ropes, Richard's sister, served as the *Woodlake Echo*'s editor. Residents remember her walking up and down Woodlake's streets, poking her face in windows and gathering news such as "Elizabeth Hansen Has Party On Fifth Birthday." (Courtesy of the Tulare County Library.)

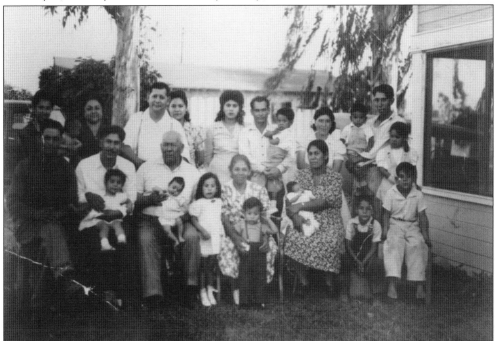

The Gomez family moved to Woodlake in the 1940s. Esteven Gomez bought several lots on Pomegranate Street and built two homes, a café, and a grocery store. His grandson Paul Gomez graduated from Woodlake High School in 1962. Paul Gomez became one of the first bilingual people on the police force in 1965, served as Woodlake's mayor, and was on the school board and a member of the Lions Club. (Courtesy of Belen Gomez.)

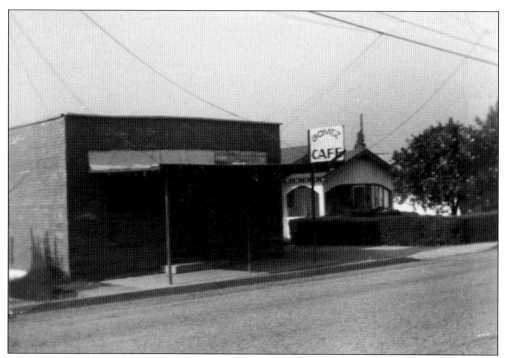

Pete Gomez opened Gomez Café on Pomegranate Street at 3:00 p.m. daily. Belen Gomez, his daughter-in-law, remembers it was her job to carry blood from the pig they roasted outside to her husband's grandmother Euletidia Gomez, who cooked the blood until it turned solid. They served it at the café along with pork skins and beer. (Courtesy of Belen Gomez.)

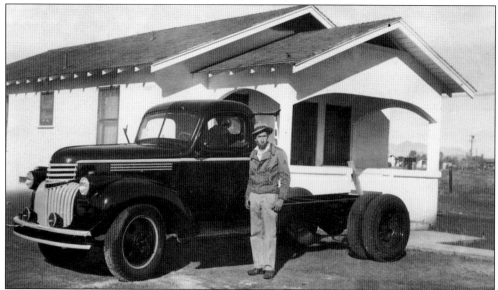

Pete Gomez and his father, Esteven Rodriguez Gomez, built the first houses on Pomegranate Street. Pete hauled chicken manure from foothill ranchers in the mountains and sold it to citrus farmers. After dumping and spreading fertilizer, "Chicken Shit Pete" parked his truck, cleaned up, and opened Gomez Café next door. Belen remembers Pete as a "funny guy." (Courtesy of Belen Gomez.)

In 1940 Oren Ruth, co-owner of Woodlake Hardware, stood with Meredith Freeman, a clerk, in the newly remodeled store. The phone number was 4. Morris Bennett had graduated in May and started work the next weekend as a refrigeration serviceman. He moved up quickly, leaving the hardware business once to serve as a glider pilot in World War II. (Courtesy of Randall Childress.)

Lawrence Bruns and his father, Bob Bruns, came from Canada, and he married Delma Smith and opened up a photography shop on the east side of Valencia Boulevard. Woodlake Hardware's unique Western brick facade appears in the far left, on the northwest side of Valencia Boulevard. The Bruns studio took many *Woodlake Echo* photographs in the 1940s and 1950s. He also played the violin in a group. (Courtesy of Richard Rasmussen.)

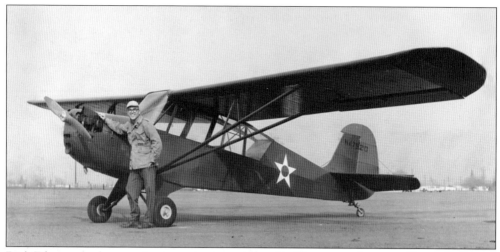

Dick Edmiston volunteered as a mechanic assisting the Chinese air force as a Flying Tiger. The American force of Flying Tigers defended China against Japanese forces. Although these soldiers made three times Army salary, they scrounged for food locally. One time, they received a shipment of vitamins, and he stuffed himself with vitamins. He is pictured here beside his 1943 Aeronca US Army L-3B, which cost him $6,500. (Courtesy of Robert Edmiston.)

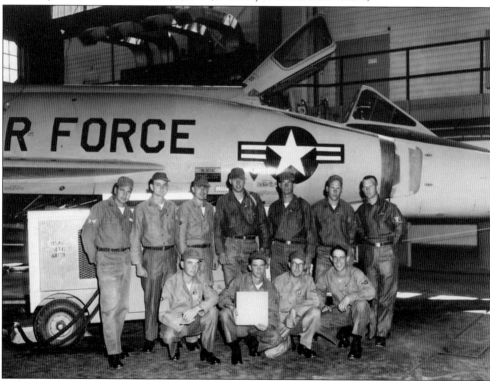

The successes of the Flying Tigers gave hope to Americans that they would eventually succeed against the Japanese. Officially, the Tigers destroyed 296 enemy aircraft. On July 4, 1942, the American Volunteer Group (the official name of the Tigers) disbanded and became part of the 23rd Fighter Group of the US Army Air Forces, which was later absorbed into the US Fourteenth Air Force with Gen. Claire Chennault as commander. (Courtesy of Robert Edmiston.)

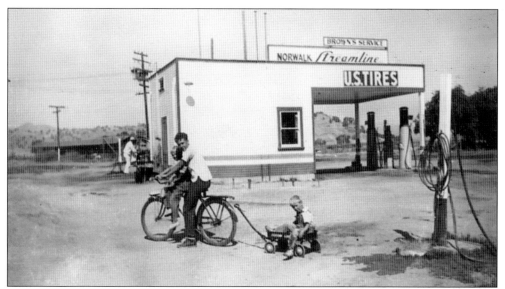

Elderwood Market, on the corner of Highways 201 and 245 and operated for years by Bill Spalding, Bonnie's son, was the last place to get gas before going up into the mountains past Badger. Just south of Elderwood School, it was a popular gathering place for ranchers, truckers, and children to catch up on local news and keep their transportation running smoothly. (Courtesy of Laura Spalding.)

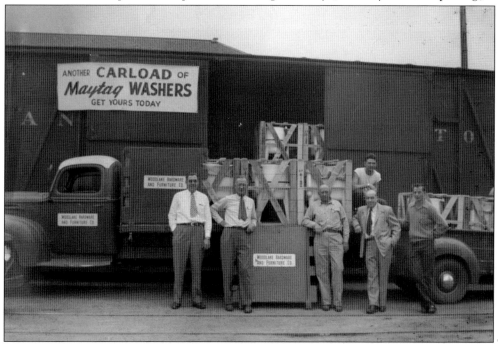

The current owner of Woodlake Hardware, 92-year-old Morris Bennett, stopped processing his paint order to describe details from this 1946 photograph. "We received Maytag orders in the loading area behind the store." Standing from left to right are (first row) John Eppling (Maytag salesman), Paul Krehbiel and Oren Ruth (Woodlake Hardware owners), Allen Savage (salesman), and Bill McPhail (clerk); (second row) unidentified. (Courtesy of Woodlake Hardware and Randall Childress.)

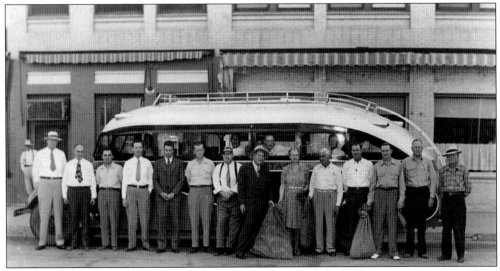

The first Orange Belt bus brought mail from Visalia on July 7, 1944. Dignitaries pictured here are, from left to right, (standing) unidentified, Dick Ropes, Francis White, C.J. Richardson, T.S. Hayworth, Al Pigg, Lorney Payne, Ivanhoe postmaster Pritchard, Woodlake postmistress Edith Day Kress, Visalia postmaster Rufus Connely, Sam Smith, Lemon Cove postmaster O.P. McCuiston, W.M. Starns, and John Packer; (on the bus) Bill Hass, Paul Krehbiel, and J.W. Harvey. (Courtesy of Marcy Miller.)

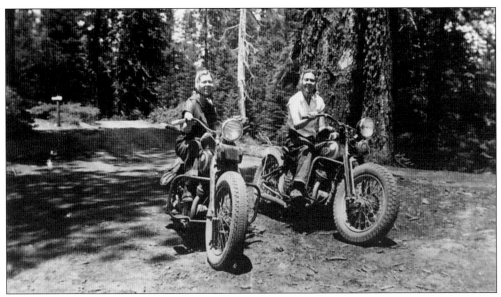

Heading north past Elderwood Market on California Highway 245, adventuresome women enjoy motorcycling to the tiny mountain community of Badger and beyond to the Sequoia National Park. Windy roads made biking as thrilling as riding a roller coaster. Summertime temperatures dropped several degrees as the tree size increased and the altitude climbed to over 3,000 feet in the 17 miles to Badger. (Courtesy of Laura Spalding.)

Longtime residents Tom Baker and Leon Morrill did not allow the snow to hamper their hunting trip. Residents from Woodlake often vacationed in the mountains, hunting deer, bear, and mountain lions. The July 1948 *Sunset Magazine* front cover pictured longtime packer Roy Davis Sr. The caption advertised, "The mountains still offer detachment from our noisy, clanking mechanized world." Visitors poured into the area. (Courtesy of Laura Spalding.)

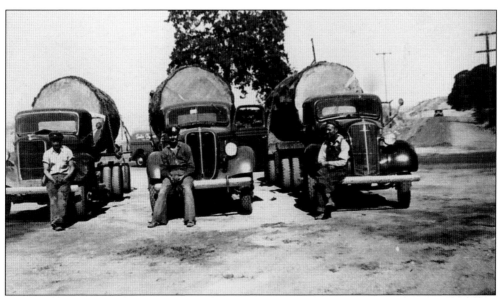

In the 1880s, the dangerous journey down the winding dirt road from the mountains to Elderwood with a logging wagon took one day. Bonnie Spalding trucked logs in the 1940s from the mountains to his lumber stores in Woodlake and Visalia, sometimes making three trips a day. The Spauldings' gas station at Elderwood Market marked the halfway point between Visalia and Sequoia Lake. (Courtesy of Laura Spalding.)

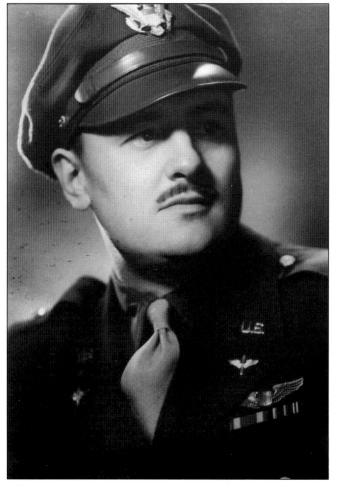

Ina Bachmann graduated from Woodlake High School in 1940. In this 1943 photograph, she stands near Avenue 364 on Road 196 gazing toward the north end of Colvin Mountain. After she married Kenneth Glentzer, she moved to Road 197. She taught at Elderwood School and made $1,800 in her first contract year; 35 years later, her salary had increased to $18,000 per year. (Courtesy of Keith Glentzer.)

Not all men in agriculture served in the Army, as the United States recognized the importance of the agricultural industry during wartime. Nonetheless, many Woodlake residents served the military with distinction. Monica Pizura's father, James Edward Robinson, served as a fighter pilot in World War II. He flew the virgin flight of the B-17 Flying Fortress pictured in *Life* magazine on its way to England. (Courtesy of Monica Pizura.)

Harold Hengst raised pigs in Elderwood in the early 1940s. Hogs ate dirt and scraps and lived in simple A-frame houses and open-front wooden sheds. Farmers preserved pork by canning, smoking, and curing. Lard was in demand during wartime as a source of nitroglycerine for explosives. Growers discovered the importance of controlling pigs' diets in the 1930s and 1940s and added foods rich in amino acids. (Courtesy of the Hengst family.)

Woodlake had a place for working women from the earliest times. Pioneer women churned butter and planted orange groves. Many Woodlake women served as teachers, nurses, and shopkeepers. Edith Kress served as the first postmistress, beginning in 1932. This 1924 Christmas photograph shows the Blairs. From left to right are Ollie Franklin Blair, Elsie Blair Day, Ruth Blair McClintock (nurse), Lulu Blair Moore Kress, and Edith Blair Day Kress. (Courtesy of Marcy Miller.)

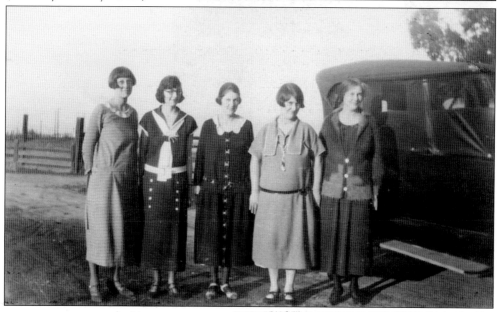

69

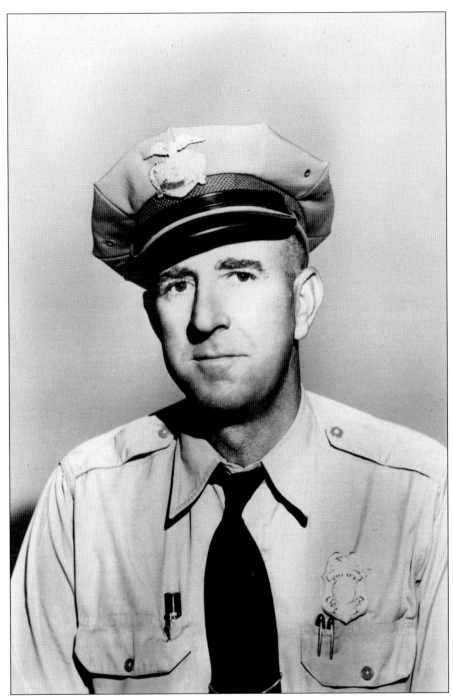

After moving from Missouri with his wife, Mary, Gus West worked on Hill Ranch before moving to town. He bought a home, and when the town policeman resigned, Gus West's neighbor E.E. Payne recruited him for the job in 1941. Gus West epitomized *Mayberry RFD* as chief of a one-man Woodlake Police Department. "I was the Chief and the Department," he laughed. In 1958, he was elected judge in June and took office in December, serving until he retired in 1977. (Courtesy of Bill West.)

Four

WOODLAKE
BECOMES MAYBERRY

As the 1950s began, the nation whirled back into economic recovery for some. The Bracero Program was still in effect and farm equipment continued to improve, but working conditions for farm workers nationwide lagged. The Bracero Program started in 1942 with agreements between Mexico and the United States allowing millions of Mexican men to come to the United States to work primarily in agriculture for short periods of time and then return to Mexico. It continued for 19 years and made agriculture in the United States the most productive fields on the planet. In small-town Woodlake, children of farm owners and workers went to school together. Teenagers hung out and shopped and danced on Saturday nights at McKay's Point. Gus West patrolled the streets of Woodlake, keeping citizens safe from harm. Courtney McCracken, the town's richest bachelor and philanthropist, drove up Valencia Boulevard, stopping daily to visit *Woodlake Echo* editor Gladys Ropes. Parade committees sprang into action, as the Woodlake Lions adopted the Woodlake Rodeo. Community service clubs spruced up the streets and public grounds. City employees' salaries increased $15 per month. Bakersfield Box Company thrived. Life in Woodlake could not have been more like *Mayberry RFD* if A.P. Haury and Gus West had written the script themselves.

Then, the flood of the century hit on December 21, 1955, taking with it the dam at McKay's Point and many bridges in a 100-mile area of Tulare County. This flood spurred county planners to finalize plans to build Terminus Dam in Three Rivers, east of Woodlake. Even with Terminus Dam, another damaging flood hit Woodlake in 1969, just as three small manufacturing plants opened in Woodlake.

As the decaying Brick Block came down in 1961, other buildings and facilities saw improvements in the 1960s. Ned Baker, clerk of the Woodlake High School Board of Trustees, honored lifelong Democrat Courtney McCracken at the dedication services for the new library building on April 30, 1966. The city's facelift included the high school gymnasium and pool, city and county offices, and the veterans' memorial building.

By 1971, optimism for exponential growth in Woodlake climaxed with the expectation that Disney Productions would construct a $35-million ski resort at Mineral King, estimated to attract 14,000 visitors each weekend and creating 250 new jobs. Strategically located at the base of the mountain, Woodlake anticipated much of the secondary development. Two major land development companies prepared plans for developments, but things changed.

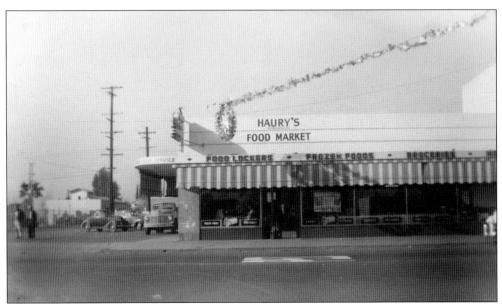

In 1946, A.P. Haury opened his new store on the west side of Valencia. A devout Mennonite, he did not sell liquor, so a liquor store squeezed into the Lake Theatre. When the store sold to the Gongs, the theater and liquor store became the parking lot on the north, and they enlarged General Foods into Haury's former parking lot. (Courtesy of Marilyn Young.)

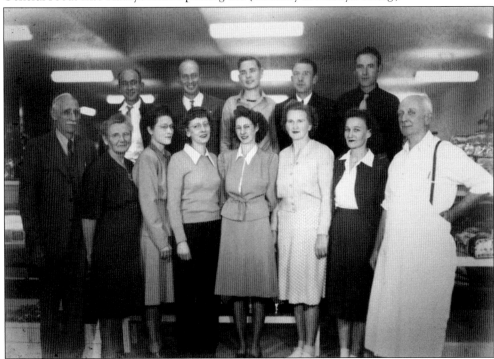

The 1946 grand opening employee photograph included, from left to right, (first row) A.P. Haury and his wife Mary; Cora Shields, secretary to Haury; two unidentified clerks; Miriam Haury, Clement Haury's wife; Alta Cornish; and Al Pigg, the butcher; (second row) three unidentified men and Melvin and Clement Haury. (Courtesy of Marilyn Young.)

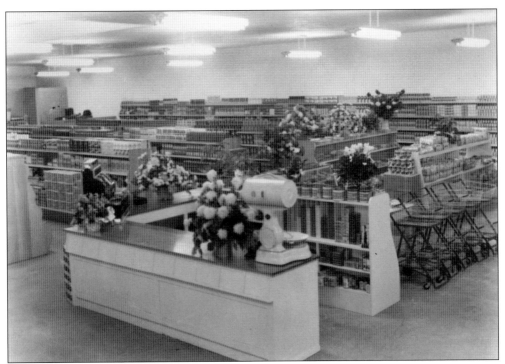

Always meticulous and a little imposing, according to his granddaughter Marilyn Young, A.P. Haury kept every can in order, all carts lined up, and the checkout counter spotless. At the back of the store, customers could rent meat-freezer lockers. The freezer lockers sat on a motorized track conveying lockers to a door so patrons did not have to go into the cold. (Courtesy of Marilyn Young.)

Brent Hamlin (left), unidentified (middle), and city clerk Pete Legakes (right) discuss possible sewer plans in the early 1950s. City trucks in the background stand ready to serve the public needs. Legakes served as mayor in the 1970s, when the town continued to face draining and sewage problems after the 1969 flood. (Courtesy of Marcy Miller.)

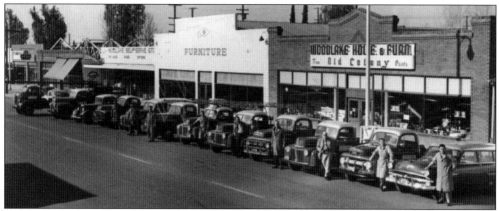

Oren Ruth and Paul Krehbiel expanded their thriving hardware business to Ivanhoe and Visalia. By 1953, when this photograph was taken, Woodlake Hardware had a fleet of servicemen and vehicles that made house calls to repair appliances. Both owners died in 1956, and Morris Bennett took over operations. (Courtesy of Woodlake Hardware and Randall Childress.)

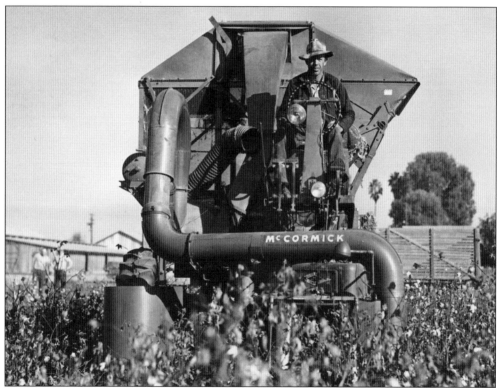

The use of better farm equipment improved agricultural production while curtailing the need for intensive labor. Fred Edmiston raised some cotton in Elderwood, but the primary business was harvesting. After he and his brother Frank modified his new cotton picker to make it easier to operate and improve function, Fred used his equipment to harvest cotton for farmers in Visalia, Farmersville, and Tulare. (Courtesy of Robert Edmiston.)

Charles "Smokey" Crumly (in back) and his younger brother, Chris, do a cool car pose with their mother, Mary Ruth Crumly. The family matriarch served as den mother for the Scouts, reported for the *Woodlake Echo*, and timed races for the Tiger Sharks and high school swim teams. After graduating in 1968, Smokey attended Hayward State on a football scholarship and returned to Woodlake as a police officer. (Courtesy of Chris Crumly.)

This photograph taken from Colvin Mountain in the early 1950s of the Bachmann Ranch shows that Dutch Colony, established in 1913 about two miles west of Woodlake, remained primarily agricultural, while Woodlake developed businesses. Kenneth Glentzer finished building his new home on Road 197 in 1952. Cottonwood Creek flows in the background. (Courtesy of Keith Glentzer.)

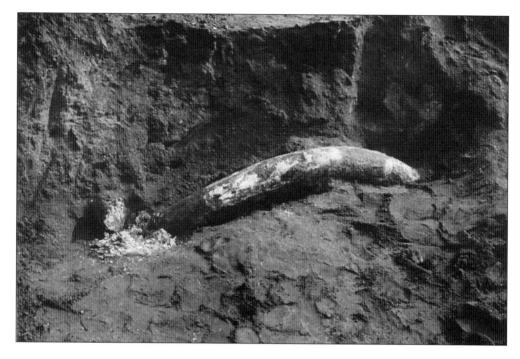

Virgin soil near Woodlake stored many valuable surprises. In 1965, Keith Glentzer watched while scientists from the University of California excavated a seven-foot mammoth tusk, measuring eight inches in diameter, found on Dan Denton's property just outside Woodlake. Just a foot-long piece weighed 30 pounds. Scientists encased the tusk in plaster to move it to the Museum of Paleontology. (Both, courtesy of Keith Glentzer.)

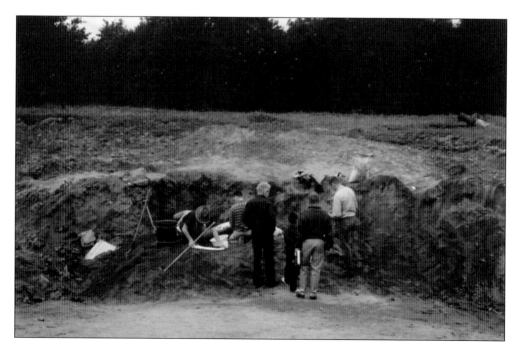

North on Highway 216 on the west access road sits Redbanks' Spanish-style building resembling a Southern Pacific depot, built in 1914. This building had a large restaurant managed by "One-Eyed Wylie," the Chinese cook. In 1932, the upstairs was converted into a five-room apartment known as the penthouse, and the east half of this building housed bachelor workers, earning it the name "hotel." (Courtesy of Carl Scott.)

The Griffith brothers renamed Redbanks Fruit Company the Redbanks Packing Co., remodeled the metal hay barn into a packing facility, and tore down the old packinghouse. They still used the old implement building, many times repaired and remodeled, but built an additional implement shed on the side of the mule stables. (Courtesy of Carl Scott.)

The California State Legislature presented Man of the Decade Courtney McCracken Resolution 133 for his 80th birthday on February 17, 1971. US presidents, members of Congress, governors, and other political leaders consulted Courtney McCracken. He donated the $134,285.92 for the county library building and furniture, $75,913 for the 1960 pool and the land for the Woodlake High School Farm and the city park. (Courtesy of the Tulare County Library.)

Woodlake doubled in size from 1940 to 1947. It had retail conveniences and the lowest tax rate in the county at $1 per $1,000. Families that came to Woodlake stayed in Woodlake and invited friends and family to join them. Agribusiness and Bakersfield Box Company brought needed jobs to the city, and an excellent school system kept people close at hand. (Courtesy of Woodlake City Hall.)

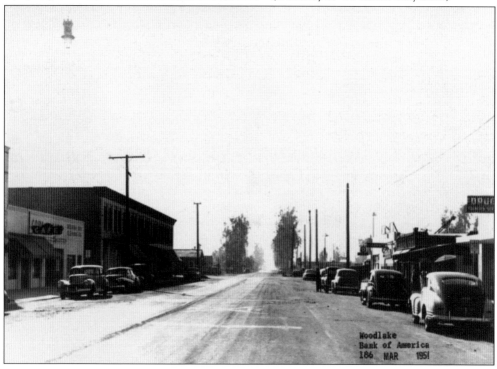

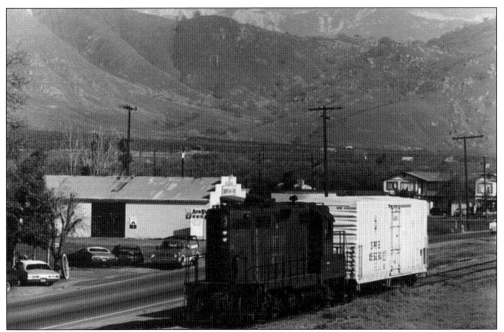

Late in World War II, deteriorating overhead electrical lines and locomotives necessitated the end of the electric system, which ceased in November 1944. Diesel service continued. However, floods in 1950 and 1955 on the Kaweah damaged lines and threatened rail service. Visalia Electric handed off refrigerator cars to the Santa Fe at Redbanks, one of four cold-storage plants along the line. (Courtesy of the Tulare County Library.)

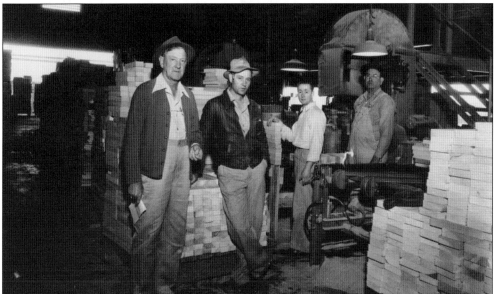

According to writer Brent Hamlin, the Bakersfield Box Co. employed about 60 persons in 1953. The sawmill specialized in making select-grade cabinet lumber and general construction materials, often for fruit crates, for as low as $35 per 1,000 board feet. A 1949 issue of the *Woodlake Echo* advertised that customers could contact manager Bill Wheeler by telephone at 137 and by teletype at 215. (Courtesy of Marcy Miller.)

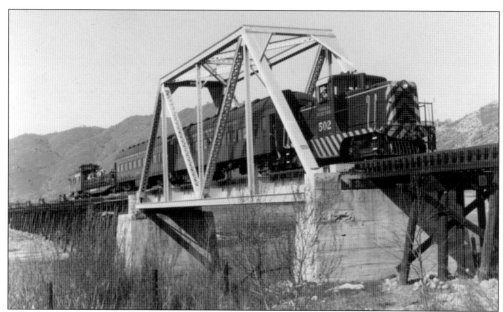

On February 20, 1955, a special four-car chartered excursion train departed for Woodlake and Elderwood with 100 passengers on a "Once an Interurban" excursion. Railfans from sponsors Bay Area Electric Railroad Association of San Francisco, as well as local residents, enjoyed lunch hour in Woodlake, where the Woodlake Chamber of Commerce greeted passengers with boxes of navel oranges. (Courtesy of the Tulare County Library.)

The surrounding area residents remained vital to Woodlake's community spirit. Abe and Bertha Dinkins built their Elderwood residence in 1948. Someone estimated that the open house attracted around 1,000 viewers. By the 1970s, their home became the polling place in Elderwood. Abe Dinkins, a logger, claimed he discovered Crystal Cave, now part of Sequoia National Park. (Courtesy of the Hengst family.)

Community activities and service organizations helped to pull Woodlake residents together. The 1954 Pioneer Roundup Committee illustrated the tenacity of Woodlake residents, children or grandchildren of the pioneer families, whose continued residence contributed to Woodlake's growth and stability. Pictured here are, from left to right, (first row) Viola Woodward and Grace Pogue; (second row) Edith Blair Kress, Hazel Payne, Bertha Ragle, and Orvis Woodward. (Courtesy of Marcy Miller.)

After World War II, doctors in the United States began treating tuberculosis with an effective, attenuated bovine-strain tuberculosis vaccine first used on humans in France in 1921. Testing, vaccination, and pasteurization of milk drastically reduced deaths from tuberculosis in the United States. Mobile medical units came to Woodlake in 1953 and took x-rays of 227 Woodlakers. June Tabor and the Lady Lions handled registrations. (Courtesy of the Tulare County Library.)

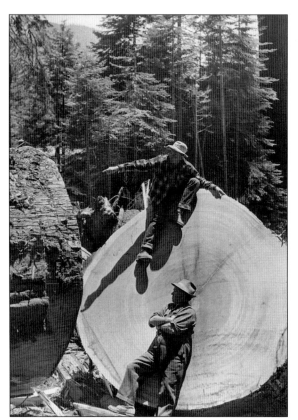

Community symbols help residents celebrate their strengths. Abe Dinkins, standing on the ground, cut down the redwood trees that became the College of the Sequoias giant and Paul Bunyan at the Three Rivers Museum. He is pictured here with Carl Barnes, the artist who carved the giants. Difficult to cut, this tree fell before it was intended and left a jagged spike on the stump. (Courtesy of the Hengst family.)

This 1957 photograph reminded residents of good times at Lake Theatre. On January 6, 1948, moviegoers watched *Moon Over Montana*. Richard Rasmussen remembers playing games in the projection booth with retired judge Al Horton, the owner's brother, who ran the projection equipment. Sometimes, the audience yelled to get the next movie started. Ernie Garcia appreciated the cute girl in the box office, Ernestine Gutierrez (Garcia). (Courtesy of Woodlake City Hall.)

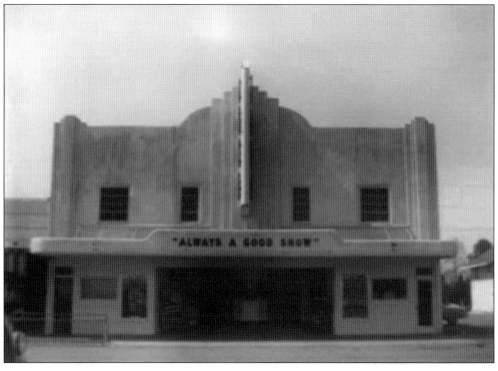

Chief Gus West treated teens with humor and kindness. One teen carried his gun down Main Street without thinking. Instead of throwing him into jail for carrying a weapon, West told him to walk a block away where no one would notice. When kids broke streetlights, West punished them appropriately. Rather than tell their parents or charge them a fine, he had them replace the lights. (Courtesy of Bill West.)

After building the police force to three, Gus West took over Woodlake's municipal court as judge in 1958. He told his successor in 1977, "Sometimes you can't follow the letter of the law and mete out justice at the same time. I've tried to hand down sentences that I felt would do justice." He stepped down when California law declared that non-lawyers could not serve as judges. (Courtesy of Bill West.)

83

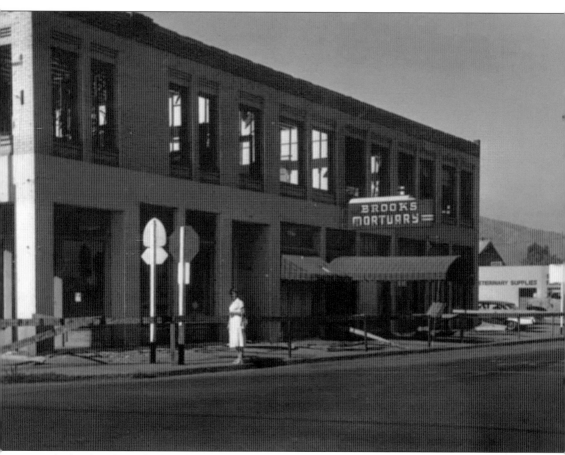

The landmark Brick Block at 100 North Valencia Boulevard welcomed all into Woodlake until its demolition in 1961. It cemented memories. Steve Webb, Woodlake's realtor, lived upstairs and worked downstairs. The Church of Christ, founded by Joel F. Coppinger, met in the Brooks Funeral Home in the 1930s. Bank of America moved into the Brick Block in 1936 and left in 1953. Muz Mullin's family lived and served the community in the Mill Inn, where Grover Kite rented a room. Robert Edmiston remembered a story when someone had a heart attack and died during a funeral at Brooks Funeral Home. Stan Livingston recalled that it took a long time to tear down. Reflecting the change in times, Mohawk full-service gas station assisted customers on the road to visit Sequoia National Park. (Courtesy of Woodlake City Hall.)

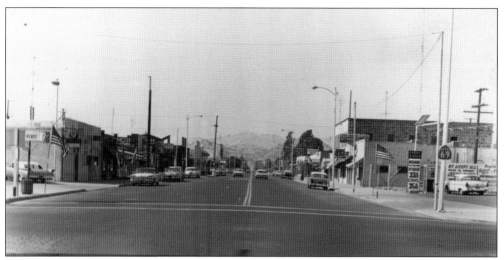

In 1949, after he went to watchmakers, engravers, and jewelry school in Kansas City, Missouri, Darold Davies returned to Woodlake and bought a store on Valencia Boulevard. He ran Davies Jewelry for 38 years. By 1961, new businesses had come and old ones folded, including Haury's Grocery. (Courtesy of Woodlake City Hall.)

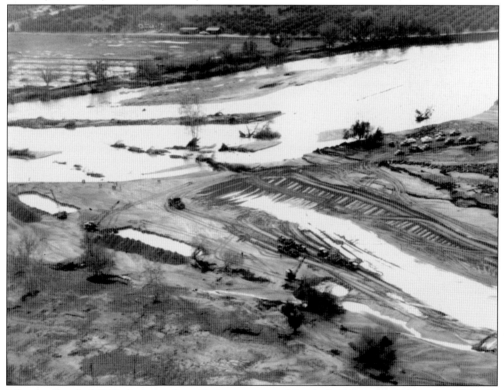

Like the flood of 1867 that wiped out Stringtown, resulting in building the 1870 rock-and-brush dam at McKay's Point, destruction from the 1955 flood motivated the Corps of Engineers to build Terminus Dam on the Kaweah River. This 1955 view of McKay's Point shows St. John's River on the right. The popular dance hall at McKay's Point closed permanently. (Courtesy of the Tulare County Library.)

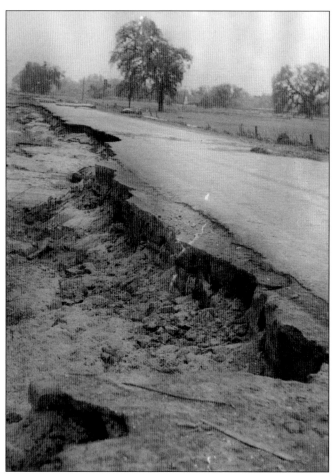

The 1955 flood destroyed Road 196, one of the main roads into Woodlake from Highway 198. In 12 hours, 12 inches of rain fell, melting the 10-foot snowpack. Living two miles south of Woodlake, Earl Mann reported over five feet of water in his parents' home, and Hap Baker rescued them in a motorboat around 10:00 a.m. on December 21. (Courtesy of the Tulare County Library.)

During the 100-year flood in 1955, Woodlake's Norwalk Vault on Antelope Creek flooded. Richard Rasmussen worked there at age 18. Norwalk made vaults with sealers around the lids to make them watertight. Norwalk concrete vaults cured for 21 days before they could be used. Joel and Carol Foster bought the building in 1985 to store ranch equipment. (Courtesy of Richard Rasmussen.)

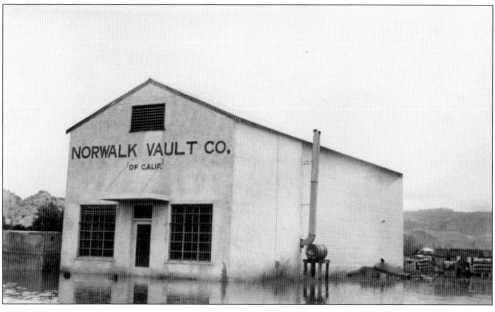

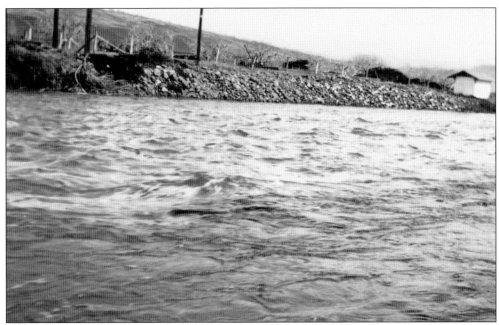

The Redbanks area, not normally in a flood area, experienced high waters during the flood of 1955. Dry most of the year, Cottonwood Creek almost overtook its banks. The Friant-Kern Canal siphons under Cottonwood Creek at Redbanks, and Fred Edmiston worried that it would not be big enough to handle Cottonwood Creek in a flood stage, but it was. (Courtesy of the Tulare County Library.)

Hijinio and Delores Reynoso herded cattle in Weed, California, before they moved to Woodlake in 1961. They built a house in 1969 and remembered the flood on January 16, 1970, because they moved their belongings by boat. Don Joaquin Escarsega (front) and Hijinio Reynoso float down the street near Pomegranate Street. The two-story house behind them remained after the flood. (Courtesy of the Reynoso family.)

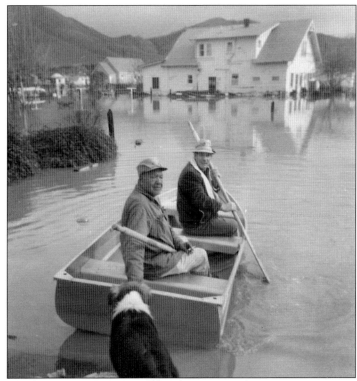

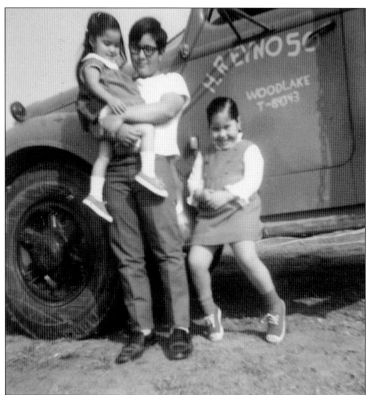

Most of the industries in or around Woodlake stemmed from agriculture, trucking companies, and feed stores to running harvesting equipment and labor contractors. In the early 1970s, Hijinio Reynoso and his two oldest sons ran three trucks hauling melons from Imperial Valley to Los Banos, olives from Exeter, and oranges from Woodlake. Pictured here are, from left to right, Rosie, Frank, and Esther Reynoso. (Courtesy of the Reynoso family.)

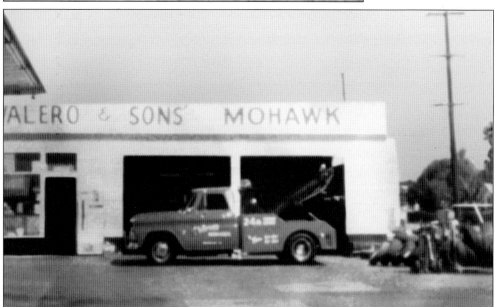

In 1956, Guillermo Valero moved his family to Woodlake, where he and his sons labored on ranches. In 1972, he and his son Humphrey Valero opened Valero and Son Towing at 100 North Valencia Boulevard. The business moved in 1978, becoming Valero Brothers. Guillermo Valero rode as rodeo grand marshal in 1982, and the three brothers, Jess, Al, and Humphrey, had that honor in 2001. (Courtesy of Humphrey Valero.)

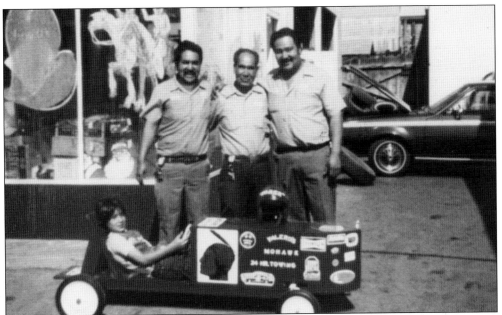

Al Valero doubted that Valero Brothers could continue to exist when they moved and dropped Exxon, their full-service gas station, and concentrated on towing. Decades of service proved him wrong, as they rescued residents and visitors stranded by dead batteries, flat tires, and even a Woodlake police car that tried to enter a brick building for a haircut. (Courtesy of Humphrey Valero.)

The towing company enjoyed a close connection to Bob Wiley and Bill Whitman, Tulare County sheriffs, as well as the Woodlake Police and Fire Department, for the work it did for the community. When patriarch Guillermo Valero passed on, the Valero brothers felt the full support of the Woodlake community for all the goodwill that their father had accrued throughout the years. (Courtesy of Humphrey Valero.)

Dr. Frank Clarke, Woodlake's 1961 man of the year and 2002 rodeo grand marshal, delivered over 2,000 babies at his Woodlake clinic. He examined students as the school doctor for 21 years and was the team physician for the football team for 28 years. A Native American, Dr. Frank Clarke served both in World War II and the Korean War as a Navy corpsman. (Courtesy of Lisa Kilburn.)

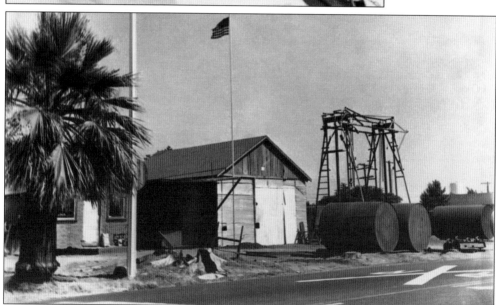

A.R. and G.W. Mosier started Mosier Brothers and began building steel tanks in 1945 on the north side of Naranjo Boulevard, across from Rusty's Drive-In. Their steel tanks, built in a variety of sizes, held mostly fuel and sold mostly to oil companies around the state. Local citrus farmers stored fuel for running wind machines and weed oil in steel tanks. Cranes moved the heavy tanks. (Courtesy of Carl Scott.)

In spite of setbacks, Woodlake expected to achieve major economic growth in the 1970s. The "Profile of Opportunity . . . Woodlake California" reported, "Walt Disney Productions will construct a 35 million dollar ski resort at Mineral King, estimated to attract some 14,000 visitors each weekend." Unfortunately, one of the two Disney scouters died in an avalanche that destroyed the store, and the other one narrowly escaped. That dream died. (Courtesy of the Hengst family.)

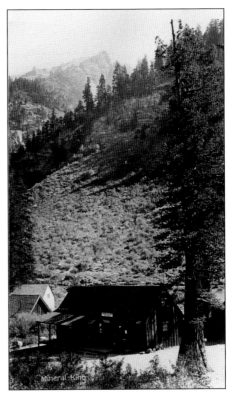

The town of Woodlake became a bedroom community of Visalia, the county seat 19 miles away. Freeway 198 into Visalia, completed in 1965, increased options for those who wished to maintain their lifestyles at home on the range in a Western ranching town. This 1970s photograph of Gary Davis could be replicated with young people in many families who still participate in ranching and the rodeo. (Courtesy of Gary Davis.)

The Woodlake dream lived on in spite of hardships. Gary Davis and his grandfather discuss the future in the 1970s. Woodlake as a western mecca for rodeo lived on. Farming, ranching, and other businesses that supported agriculture provided the bulk of the economical resources in the 1860s and continued to do so into the 1960s and 1970s. (Courtesy of Gary Davis.)

Five

EDUCATION AND
RELIGIOUS FOUNDATIONS

Even though the settlers did not rush to build a town, they established a church for their spiritual life in 1866 and a school for their children in 1870. Both institutions played the dual roles of being the community centers as well. Early elementary school names captured the essence of pioneer days: Antelope, Naranjo, Elderwood, Townsend, St. Johns, Lime, Paloma, Elda, and Jefferson Davis. Two buildings remained into the 21st century. The crumbling vestiges of Elda School, established in 1911, deteriorate on Millwood Drive near the rodeo grounds, while Jefferson Davis School, from 1880, serves as a bunkhouse in a private residence. Schools in Woodlake Valley merged as transportation improved, students outgrew the buildings, or the buildings became outdated or unsafe.

From pioneer days to the 1950s, some teachers boarded with residents. Grace Pogue wrote, "Room, board and laundry cost $15 a month [at the J.D. Waugh place]." Early teachers earned $50 to $65 per month for the six-month term. Antelope School averaged 18 students. By the 1900s, many teachers came from the ranks of the Woodlake citizenry. However, Robert Hengst remembers when Martha Friesen and Ellenora Voth lived with the Dinkins in the 1950s. School and home life became more interesting for him. The Presbyterian church, the first and largest church in the community, started in 1868. Jonathan Blair donated his time as the minister for 20 years. The congregation met in Antelope School from 1895 to 1913, when it built the cement-block church. In the early 1900s, a Methodist church also held services. By 1948, Church of Christ, Assembly of God Tabernacle, and the Baptist church held services in Woodlake, and in 1963, the Catholic church began services.

Schools and churches well into the 1960s existed partially on the philanthropic efforts of generous residents. James Henry Blair donated land for the Antelope School, the Presbyterian church, and the cemetery. Abe Dinkins donated some of the Elderwood property inherited from Melvin Woodard for the Townsend, or Elderwood, School. Years later, Courtney McCracken donated money to build the county library building and the pool and the land for the school farm and the city park.

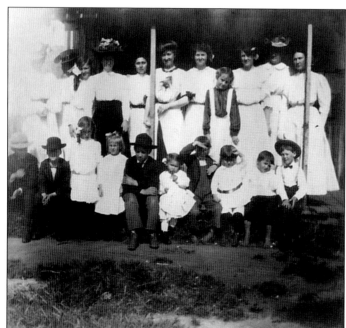

According to Grace Pogue, in 1870, Thomas Davis employed John Hill to teach his sons and the Fudge and Barrington children in the Davis sheep shed. Jefferson Davis School, which formed in 1880, hired Erma Ricker (Edmiston), from San Diego. Her photograph album documented the last day of school with her class in May 1907. Rooming with the Fudges, she met her husband, Tom Edmiston, that year. (Courtesy of Robert Edmiston.)

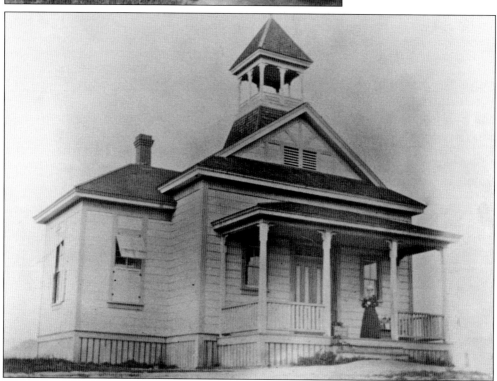

Organized on May 2, 1870, Antelope School moved from Moffett property to Blair property in 1895. According to Grace Pogue, this building had served as the Good Templars Hall in Elderwood. Workers painted it white and added a belfry and spire, altar, reed organ, and pews. D.B. Day wired it for electricity. It served the community until 1913, when a brick building was erected next to it. (Courtesy of Marcy Miller.)

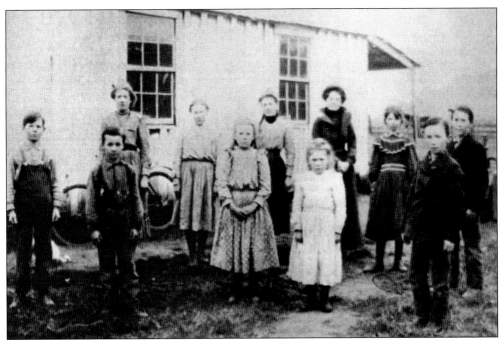

The 10 students and one teacher included, from left to right, (first row) Oscar Clarkston, Philip Davis, Geneva Shipley (third or fourth from left; the other girl is unidentified), and Roy Davis; (second row) Maude Shipley, Gertrude Fudge, Clara Shipley, teacher Annie McNary, Rena Clarkston, and an unidentified boy at Antelope School in 1902. Roy Davis, born in 1891, became a pack station operator for 30 years in Mineral King and served in Europe during World War I. (Courtesy of Robert Edmiston.)

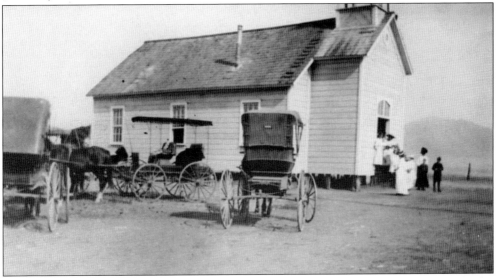

The first full-time pastor after Jonathan Blair, Isaac Gaither, built the church manse. By 1893, he and his wife, Ada, helped organize the Women's Missionary Circle and Young People's Christian Endeavors. In 1896, Antelope Church hosted more than 100 delegates to the Tulare County Christian Endeavor Convention. Marion Legakes, four generations from Jonathan Blair, served as historian to preserve church history. (Courtesy of Woodlake City Hall.)

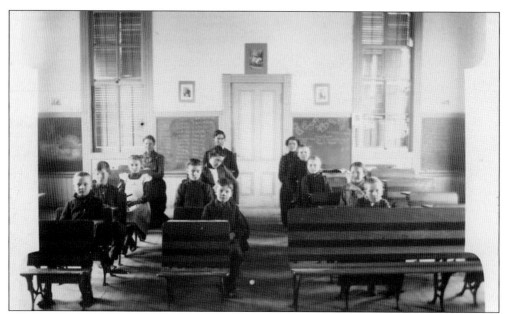

Antelope School was the first modern school in Woodlake with ventilation, lighting, graduated-sized desks, slate blackboards lining every wall, two cloakrooms, a library, and a porch for rainy-day play. The inside of the school looked typical for the early 1900s. Monetha Woodard worked either as a teacher or principal at Antelope School from 1899 until 1902, the date of this photograph. The patriotic theme included, front and center, a photograph of President McKinley, who was assassinated in September 1901. On the floor sat Secretary of State John Kay and 42-year-old Theodore Roosevelt, who became the youngest president, a supporter of the big trees. (Both, courtesy of Marcy Miller.)

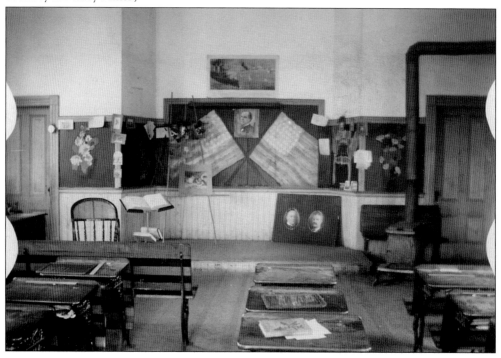

St. Johns School, named for Loomis St. John, one of the Tulare County Board of Supervisors, was organized in 1875. The original school burned down in 1887, and classes met in a temporary building. One teacher, W.F. Dean, nearly lost his life in the flood of 1889. The school remained in use as a two-teacher school for about 40 students until 1955, when it unified with Woodlake Elementary. (Courtesy of Carl Scott.)

Cumberland Presbyterian incorporated as First Presbyterian Church in 1913, reflecting the national merger, and work began in April to create the concrete building. The Women's Missionary Society and Lady's Aide donated the two stained-glass windows. The arrival of electric lights and the horseless carriage modernized churchgoing, but a church then had to compete with other engaging activities that took people away from church attendance. (Courtesy of Marcy Miller.)

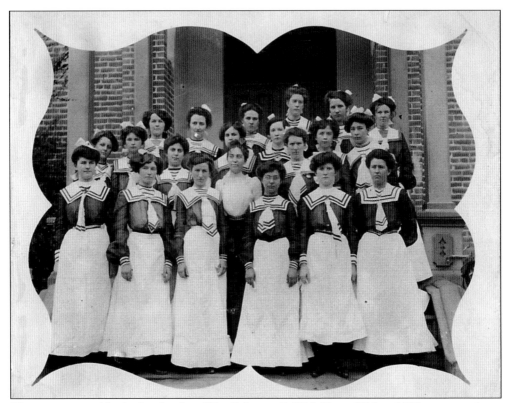

There was no public high school in Woodlake until 1914. From 1910 to 1913, some students took the Visalia Electric to Exeter High School. Robert Hengst's maternal grandmother, Bertha Dinkins (second from left in the third row), graduated from Townsend School and attended boarding school in Tulare. Tulare Union High School organized on September 1, 1891. (Courtesy of the Hengst family.)

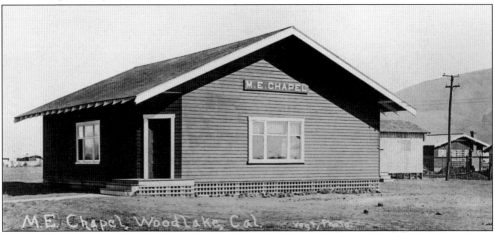

Woodlake had two churches in 1912, Presbyterian and Methodist. On June 13, 1915, H.A. Bachmann helped establish the Mennonite chapel northwest of Woodlake in Dutch Colony with 18 members. They continued to meet until January 20, 1929. Numerous Mennonites, including A.P. Haury, invested in the Woodlake Citrus Development Company before World War I. (Courtesy of Keith Glentzer.)

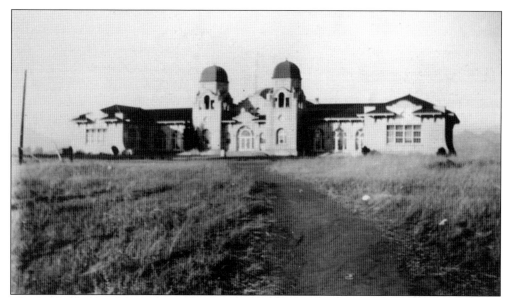

The first high school graduating class started in the Brick Block and finished here in 1917. On September 23, 1914, the first student body organized with Susie Hunter (president), Lawrence Davis (vice president), Ruth Blair (secretary), and Ross Bierer (treasurer). The class selected school colors of red and gray. An automotive shop was added in 1920 and a gymnasium in 1929. The school was valued at $50,000. (Courtesy of Marcy Miller.)

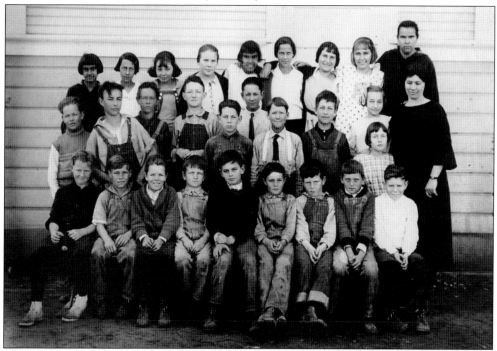

Virginia Stapp taught the 1923 Elderwood class pictured here. Each year, she greeted her students with the snap of a leather strap across her desk. "We're going to have a good year this year, aren't we?" she queried with a stern expression. Someone stole it at the end of the term, but a large strap replaced it in September. Her students called her Miss Strap. (Courtesy of Robert Edmiston.)

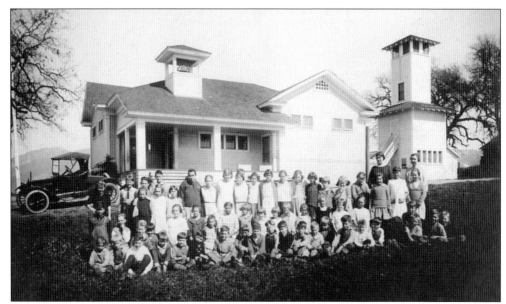

When she was not teaching, Virginia Stapp wrote the pageant *Valley of the Sun*, which made Woodlake famous in 1926. Wilma Dinkins stated, "She not only taught us the requirements, but after school we learned gardening." On Saturdays, students went to her house to make reed baskets and paint toys, vases, and other items, which they sold to buy school supplies. (Courtesy of Robert Edmiston.)

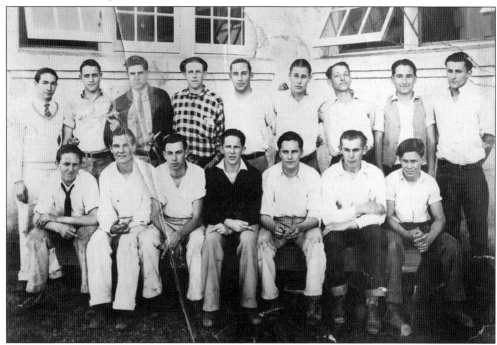

Although this photograph did not come with labels, it is most likely lettermen who organized themselves into the "Block W" Society. According to the 1928 yearbook, "Lettermen have always stood for clean sportsmanship and fair play in athletic contests." They sponsored events such as wienie roasts on the river. (Courtesy of Marcy Miller.)

The elementary school that has stood at 300 West Whitney Avenue since 1923 became unusable for students after earthquake standards became more stringent in the 1950s and 1960s, so it housed administration and staff. This earthquake-safe addition to Woodlake Elementary, on the corner of Whitney Avenue and Palm Street, was added at a later date. (Courtesy of Lisa Kilburn.)

In 1932, Buddy Saint Maria plays in the snow in front of Woodlake Elementary School. Snow-studded mountains guard Woodlake's eastern front but do not share their treasure. While the rainfall in Woodlake averages 14 inches per year over a 44-day period, the average inches of snow per year is zero. (Courtesy of Ellie Cain.)

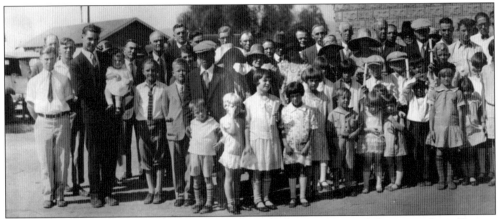

This 1930s partial photograph continues across four photographs and illustrates the influence of the Presbyterian church in Woodlake. Membership numbered 175 in 1936 but grew to more than 300 by 1944 from a population nearing 1,200. Strong lay leaders kept the church united during and in between pastors' ministries. Longtime Woodlake residents recognize children in this image. (Courtesy of Woodlake Presbyterian Church.)

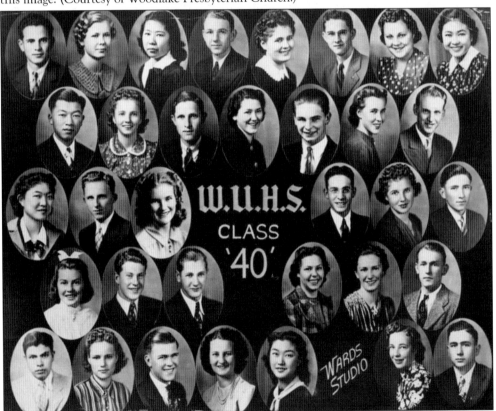

Before World War II and Executive Order 9066, Asian Americans represented 11 percent of the Woodlake graduating class of 1940. Ralph Coleman, Melvin Haury, Evelyn Bray, and Richard Ainley served as senior-class officers. "The Block W had an exceptionally active year under the leadership of its president Maurice Bennett," the *Sequoia* yearbook reported. It started the work building the giant W on Davis Mountain. (Courtesy of Robert Edmiston.)

Seen in the above photograph, standing in the back row, Sophia Marsters taught sports lovers Richard Rasmussen, Joe Hannah, and Frank Ainley at Elderwood School. Richard Rasmussen became station manager of the Visalia US Forestry Department. Joe Hanna taught school but achieved fame with his son Lonny and brother Jack as the Sons of the San Joaquin. Frank Ainley ranched his father's acres, taught, and coached at Woodlake High School. (Courtesy of Richard Rasmussen.)

Stray boards of Elda School remain beyond the Woodlake Rodeo grounds. Begun in 1881, it operated until 1908, when Townsend School was erected. According to the *Woodlake Echo*, Homer Woodard, an original member of the board of trustees, donated property to build the Townsend School, which had only two rooms. In 1926, a third room and kitchen were added, before it became Elderwood School, famous for its chicken-pie socials. (Courtesy of Frank Ainley.)

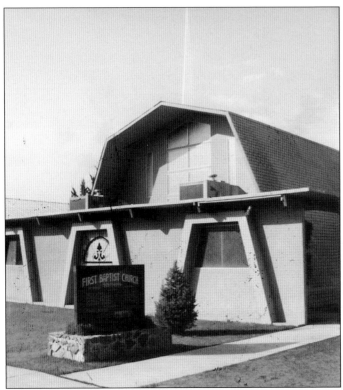

The First Southern Baptist Church began in 1944, just before World War II ended. In 1948, Pastor Leonard Rhodes, from Tulare, filled the pulpit. It outgrew its sanctuary after nearly 20 years, and construction of this new sanctuary, which holds 300 people, took its place. It converted the former sanctuary into an education wing and office building. (Courtesy of the First Southern Baptist Church of Woodlake.)

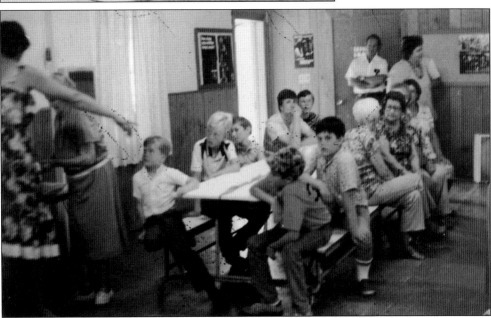

The church celebrated its 40th anniversary with a special service in February 1984, when Calvin Sarver pastored the church. Former pastors Olin Collier, Dave Wheeler, and Loren Hanson as well as the Lewis Family Singers and Elliot Smith also attended the day of festivities. Newspaper records indicated that Reverend Collier returned from the Oildale church to preach at a layman's soul-winning crusade on October 5–9, 1960. (Courtesy of the First Southern Baptist Church of Woodlake.)

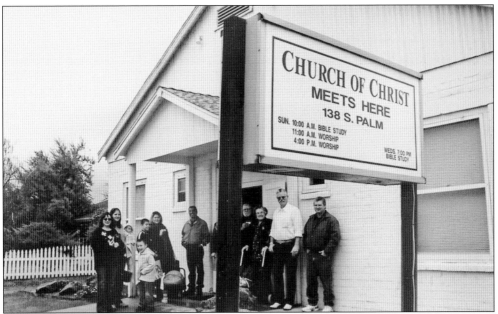

Joseph F. Coppinger established the Woodlake Church of Christ in Brooks Funeral Home in the Brick Block. Serving as the church's first pastor, in 1947 Joseph Coppinger designed and built the current place of worship on 138 South Palm Street. Truman Scott, Walter Finnel, and Sonny Malson began their preaching careers while attending the Church of Christ. Sonny Malson served as the pastor for several years. (Courtesy of Woodlake Church of Christ.)

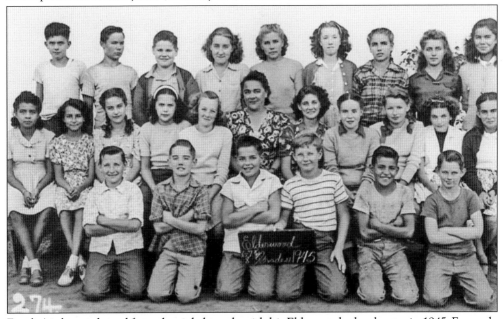

Frank Ainley graduated from the eighth grade with his Elderwood schoolmates in 1945. Formerly Townsend School, Elderwood School sat on Dinkins property on the east side of Millwood Drive, half a mile north of Elderwood Market. Tulare County inspectors determined that Elderwood School did not meet 1950s earthquake standards and had the building demolished. It closed in 1954 and officially joined Woodlake Union Elementary on July 1, 1957. (Courtesy of Frank Ainley.)

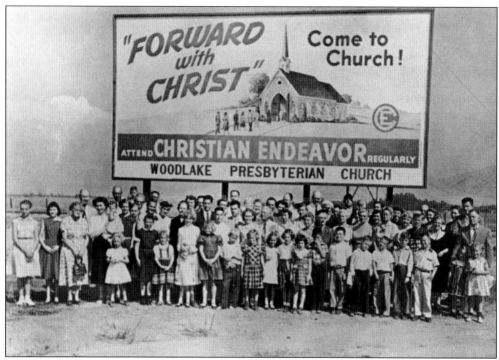

Ministers changed at Woodlake Presbyterian about every five to seven years. When this photograph was taken in 1954, Rev. John Shackelford pastored for two years between missionary service in Hawaii and seminary in San Francisco. Grace Pogue had just been ordained as the first female elder. Missionary work, women's and children's programs, and strong elders and deacons kept the church vibrant. (Courtesy of Woodlake Presbyterian Church.)

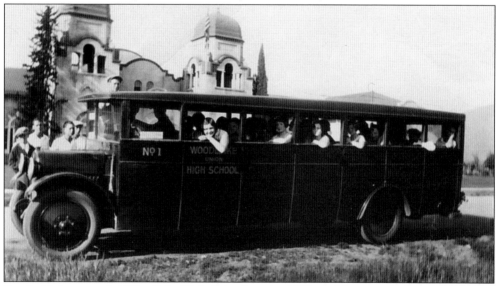

Frank Ainley attended Woodlake High School in the 1950s and later taught history there. He described the early bus routes. "Three busses ran to the high school, one from Elderwood, one from the Swamp People [St. John's area], and one from Three Rivers." This 1926 Swamp bus often arrived late during flood years. (Courtesy of Marcy Miller.)

Half a century after Woodlake Elementary was completed, instead of building another elementary school, the board of trustees authorized building the Francis J. White Learning Center, named after the longtime principal, with open classrooms for kindergarten through third grade. For the first few years, teachers tried "team teaching" all their students in one room. (Courtesy of Becky Davis.)

The original school burned on July 24, 1936, and the automotive shop burned in 1949. In this 1964 photograph, the school campus included 22 acres and was valued at $1.25 million. Fire safety mandates required remodeling in the 1970s to add classroom doors and steps to the outside. Ernie Garcia Jr. remembers a stink bomb on the steps outside the main office that evacuated the school. (Courtesy of Carl Scott.)

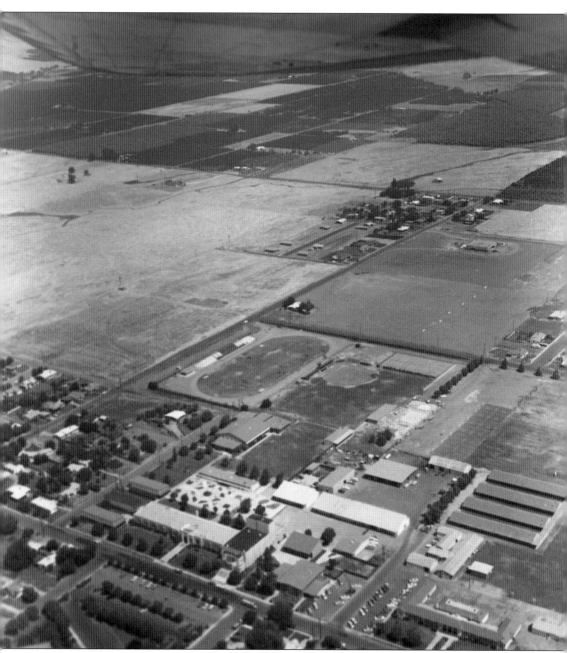

Before fire claimed the life of the auditorium, Bud Kilburn photographed an aerial view of the entire Woodlake Education Complex in the late 1960s. Woodlake High School, a white structure, with an Art Deco auditorium to its right, sits near the center of the lower third of the picture. The Veterans' Memorial building is on the south side of Whitney Avenue across from the high school. Moving east on Whitney Avenue, Woodlake Elementary sits on the lower right of the photograph. The middle school classrooms are the four long buildings on the right. Scrolling up, the new primary school sits alone, unfinished in a field in the upper-right third of the image. Close inspection shows the distinctive arched soffits around the doorways. (Courtesy of Lisa Kilburn.)

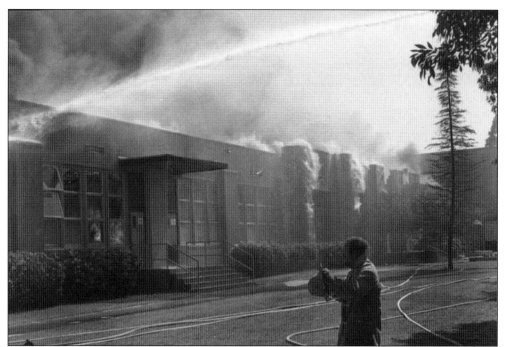

Bud Kilburn photographed the fire in 1980 that burned the high school the day after graduation, which sucked the oxygen out of the community. Volunteers Greg Whitney, Ernie Garcia, and Carl Scott remembered fighting the fire. Ernie Garcia helped Chief Joe Hughes on the roof until it became too unsafe. Moments after they got down, it collapsed. (Courtesy of Lisa Kilburn.)

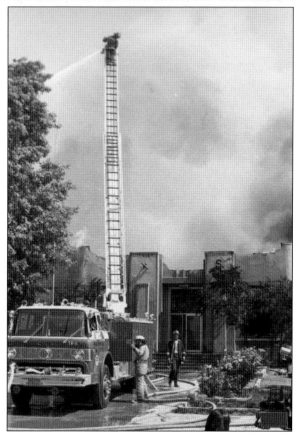

The fire started in the main office. Chief Joe Hughes thought his volunteer crew contained it, but fire snuck into the airshafts in the basement and spread to the main part of the building. Sally Pace saw pillars of smoke from five miles away. The fire did not spread to the entire school, but the auditorium, several classrooms, and valuable records and pictures lay in ruins. (Courtesy of Lisa Kilburn.)

Herman Ziggler, high school vice principal, and Tom McGee, director of maintenance and operations, made an initial assessment of the damages. Community members had removed instruments and equipment from the band room, but it and about 10 classrooms had burned beyond use. The fall of 1980 opened with nearly everyone sharing a classroom. (Courtesy of Lisa Kilburn.)

Space occupied minds of high school students in 1959. Woodlake teens in Jack Hickey's science club built a cement block launch building on Hengst property. They shot two rockets over 2,000 feet over Sentinel Butte Research and Development Test Range on April 9, 1959. One rocket landed 300 feet from Gary Davis's home. The following year, they designed safety features to destroy stray rockets by radio. (Courtesy of the Hengst family.)

Six

WOODLAKE CELEBRATES

Celebrations of past events bring communities together for a stronger future. By 1926, the 60-year-old farming communities scattered around the Woodlake Valley had faced devastating droughts and floods and the depression of 1897. They had pulled together into a tourist town and survived the effects of World War I. The Roaring Twenties and Prohibition were in full swing, and women could vote. Woodlake was a vibrant 16-year-old town ready to celebrate its successes.

Woodlake recognized its strengths and in 1926 first celebrated its Western foundations. What started as a modest graduation exercise for eighth graders from Townsend School, *Valley of the Sun*, a pageant written by principal Virginia Stapp, became the biggest, most technologically advanced celebration in Woodlake and the West at that time.

First, she reached out to the Woodlake Service Clubs, who donated financial help, then Woodlake High School District got involved. Nearby towns Three Rivers and Visalia gathered in to help. The narrator, H.B. McClure of Visalia, used a new Hollywood device, the microphone. Fox News and Pathe News filmed the pageant, and Woodlake's tradition of celebration had begun.

After that illustrious beginning, Woodlake continued to host an annual parade on Mother's Day. Weekend activities like the Whiskerino Contest took on independent lives. Community organizations planned that week of activities for months ahead of time. Rodeo Week featured a firemen's muster, soapbox derby, and an ugly dog contest, culminating with the parade on Saturday morning, the rodeo on Saturday and Sunday, and a Saturday-night dance.

Church service organizations started very early in the 1900s. With an objective to help students, Kiwanis started in the 1920s, sputtered, died, and began again in the 1980s. Numerous service organizations and celebrations proliferated in the 1940s. Woodlake Lions Charter members Tom McGee, Dr. Bill Ruth, Pete Legakes, Bill Ferry, Jack Dietz, Dennis Dalton, and Leonard Whitney founded the Lions Club in 1947. The club began sponsoring the rodeo and parade in 1953. Woodlake Rotary was founded in 1942 with the objective of being an example of pacifism and peace, using golf tournaments to raise money for projects.

When the Woodlake Rodeo Parade began in 1949, Woodlake High School junior Barbara Brewer (Ainley) was chosen as queen. "I didn't have a horse of my own. I had generous neighbors," she said in a 2004 interview. She rode again 50 years later as queen of the rodeo parade. The life of Woodlake's legendary Western icon ended peacefully on September 27, 2014, with a closing admonition to her husband to "go home and clean the kitchen." Cowgirl Barbara Ainley felt as comfortable in blue jeans as she did in formalwear and exhibited equal skills in the saddle and on the dance floor. Whether she rustled up a meal in the kitchen or bandaged bumps and bruises in the high school health center, Barbara Ainley efficiently served her community with kindness and a smile. Woodlake celebrates the life of Barbara Ainley. (Courtesy Frank and Barbara Ainley.)

The *Valley of the Sun* pageant featured a cast of more than 700 members who pantomimed historic scenes. Practically everyone in town played a role; to name a few, Wilma Dinkins played a cloud, Marion Legakes a bluebird, Wilma Cornish and Leila Haury poppies, Frank Edmiston a frog, Glenn Duncan a bee, and Alice Hawkins Mitchell a sun maiden. Visalia stores closed early for the occasion. (Courtesy of Marcy Miller.)

Sentinel Butte's amphitheater provided the stage to reenact the history of Woodlake Valley. Two Indian lovers, played by Jefferson Davis and Claire Duncan, entertained a crowd of 10,000. Costumed caravan members came from Three Rivers, including Professor Dean and Noel Britten. Gertrude Rucher from the Woodlake Presbyterian Church assembled a 200-voice choir. Funds went to build the Woodlake High School gymnasium. (Courtesy of Robert Edmiston.)

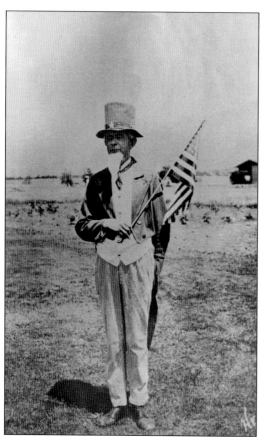

John P. Day portrayed Uncle Sam in the "Tomorrow" scene along with Miriam and Marjorie Smith as two small oranges, Mary Hein as California, Boy Scouts, two small poppies played by Virginia Hahn and Dorothy Kanue, and Happiness by Jane Severance. Clyde Keener, noted Tulare County musical director of the Visalia Theatre Orchestra, assembled more than 50 pieces to create the largest Tulare County Orchestra ever assembled. (Courtesy of Marcy Miller.)

The 1940s Woodlake City Band marched in Portuguese parades all over the county. Pictured here are, from left to right, (first row) David Peden, Anna Alden, Dick Edmiston, Ruth Kress, Melvin Haury, George Webb, director Oscar Payne (kneeling in front), Ruth Davis Pugh, Lee Grimstead, Clement Haury, Edgar Lynds, Jene Eberle, and Elmer Yocubets; (second row) Bill Lewis, Dale Brown, Jack Webb, James Parkinson, Lloyd Lucas, Ewell Blair, Turk Lynds, Eugene Frey, Art Moran, Charles Blair, Fred Rabe, and Harold Beutler. (Courtesy of the Tulare County Library.)

Woodlakers loved to dance. Print Stokes formed a country-western group, the Rocky Mountain Cowboys, which sang regularly at the Lazy A Barn at Roble Lomas Ranch. Richard Rasmussen remembers waiting in the car with his brothers while his parents danced inside the screened-in barn. Group member Joe Pohot, Mary Pohot's son, rests his foot on a suitcase, and Print Stokes stands on the far right. (Courtesy of Richard Rasmussen.)

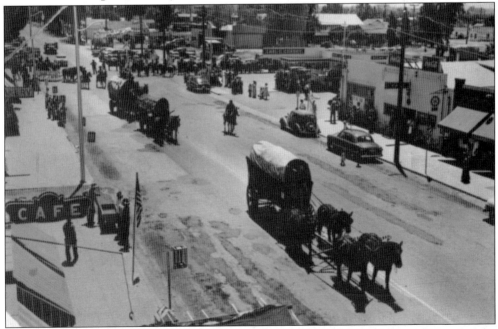

The unknown photographer faced south and probably watched the parade from the roof of the Brick Block, above Elbow's Bakery, in 1947 or 1948. The Woodlake Saddle Club hosted the miniature rodeo across from the city park before the Lions Club took over the weekend's festivities. (Courtesy of Woodlake Hardware and Randall Childress.)

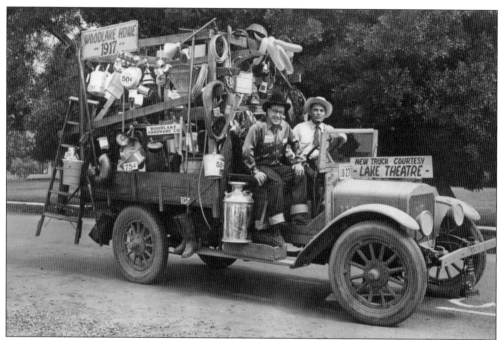

Carpenter Albert Aguilar drives the Woodlake parade truck along the 1940s parade route while Woodlake Hardware salesman Alan Savage interacts with the oglers with his milkcan handy by his side. Prices are reasonable. Buy the pair of boots hanging on the side for only 95¢, while the metal pail costs only 55¢. However, the larger watering can fetches 75¢. (Courtesy of Woodlake Hardware and Randall Childress.)

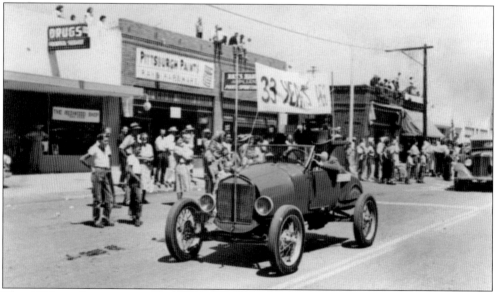

This 1950 parade car runs south on Valencia Boulevard toward Naranjo Boulevard. Facing east, parade onlookers line the roofs of Schelling's Woodlake Drug Store, Ray Lutz's Hardware, and the Woodlake Echo building, the oldest building in Woodlake at that time. A fired caused severe damage to the building and equipment in 1952. Gladys and Richard Ropes then sold the paper to W.S. Clawson and his son. (Courtesy of Woodlake Hardware and Randall Childress.)

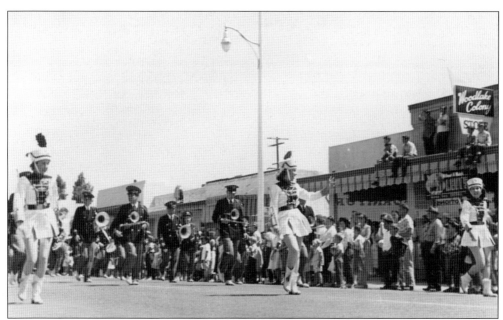

Young men watch the Woodlake High School Band march down Valencia Boulevard in front of the Woodlake Colony Clothing Store in a 1950s rodeo parade. Richard Rasmussen and his friend Jane sat in chairs along the sidelines near the old meat locker, enjoying the parade. (Courtesy of Richard Rasmussen.)

Bruns Studio photographed the 1953 centennial celebration award-winning sweepstakes float, "Melody in Spring," by the Woodlake Lions and Lady Lions. From left to right, Anita Kaun, Joyce Garcia, and Marilyn McLauren reign over the parade from under the parasol. "The orderly arrangement as planned by chairman, Peter Legakes was carried out according to previously announced plans" (*Woodlake Echo* May 15, 1953). (Courtesy of Marcy Miller.)

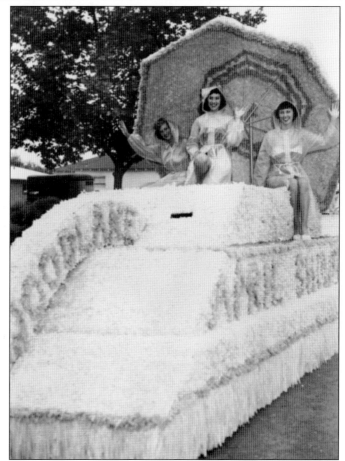

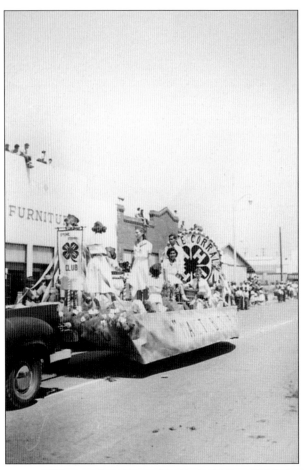

Woodlake Lions began hosting the Woodlake Rodeo along with the centennial festivities in 1953. This annual May event began drawing crowds into the thousands every year from all over the country. Grade and high schools participated, playing in bands and marching in the parade. The pictured float highlights Stone Corral Elementary School, which lies west of Woodlake. Stone Corral students attend Woodlake High School. (Courtesy of Marcy Miller.)

Pictured in front of the Brick Block are Oscar Payne (tuba), Harry Payne (baritone), Ewell Blair (trombone), Lloyd Toler (bass drum), Ralph Caudle (trombone), Nonday Payne (snare drum), David Weaver (alto horn), Bill Lewis (alto horn), Lester Caudle (cornet), Raymond Maddock (baritone), Edgar Blair (cornet), and Oliver Snyder (baritone). Harry Payne presented Oscar Payne's photograph to Woodlake. (Courtesy of Marcy Miller.)

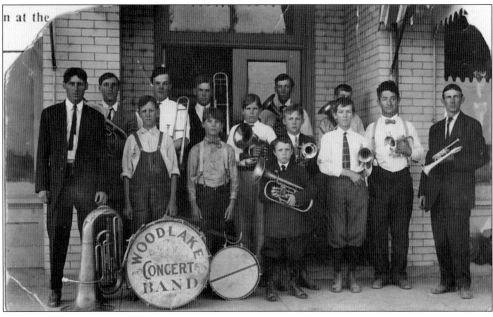

In 1951, few could compete with Arnold Burnett (left) and Pete Legakes (right) in the Whiskerino Contest, although Pat Becket and Ray Bimat provided stiff competition. Unfortunately, any male without a beard was put in the hoosegow. Otho Jordan remembers, "Dad got jailed by the pretty 'deputy' for not having a beard. Curly the barber had a real fancy beard." (Courtesy of Marcy Miller.)

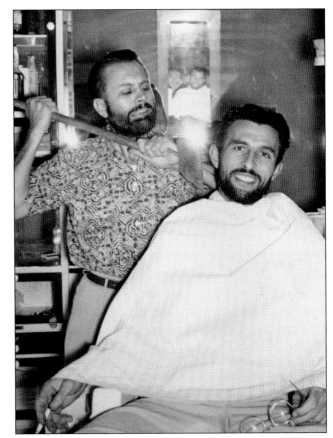

Sally Dudley's boss Robert Haden rode with his children in the May 1954 Woodlake Lions Parade down Valencia Boulevard, the main street in Woodlake. Running for district attorney, he was later elected, and Sally Dudley moved to the district attorney's office as the secretary. Gilbert Stevenson's palm trees remained a silent tribute to his vision. (Courtesy of Sally Dudley.)

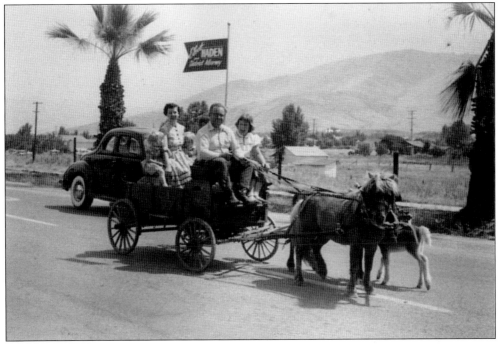

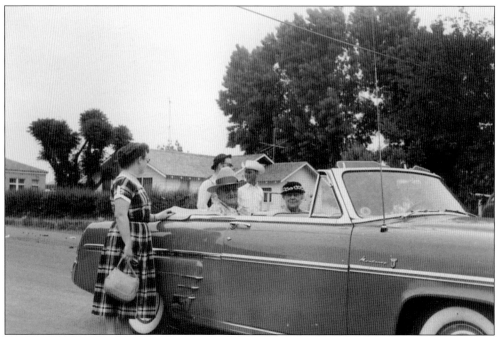

Sally Dudley (pictured) visited with her father-in-law, the 1954 parade grand marshal John G. Dudley. Brother to real estate and oil tycoon Benjamin Dudley, John G. Dudley loved to tell the Evans and Sontag story every time Sally and her family visited him. Chris Evans left a bloody handprint on their gate when he escaped from Stone Corral after the deadly shooting that killed his partner. (Courtesy of Sally Dudley.)

John G. Dudley, the youngest son of Moses and Sarah Dudley, a pioneer Woodlake Valley family, rode as the parade grand marshal in a 1953 Mercury Monterey convertible with his wife, Julie, in the 1954 parade. Gas Ranch later stood on the empty lot behind the parade car. (Courtesy of Sally Dudley.)

Betsy Griffin (Crumly), on the left, and her friend Gayle Harris (Nelson) rode down Valencia Boulevard as Wukchumne Yokuts in the 1968 Woodlake Rodeo Parade. Betsy Griffin may have already realized that she would marry Smokey Crumly, son of Hal Crumly, and would teach at F.J. White Learning Center. She could not have known she would have two children, Sara and Chris Crumly. (Courtesy of Chris Crumly.)

Each year, parade officials chose honored community members to ride as the grand marshal. Charlie Dionne, 1970's honoree, came to Woodlake in 1914 to help build Paloma School. He also worked on St. Johns and Lemon Cove Schools. Later, he clerked for Woodlake Hardware. He gave 33 years of his life as the custodian of the New Woodlake Elementary School on Whitney Avenue, built in 1924. (Courtesy of the Tulare County Library.)

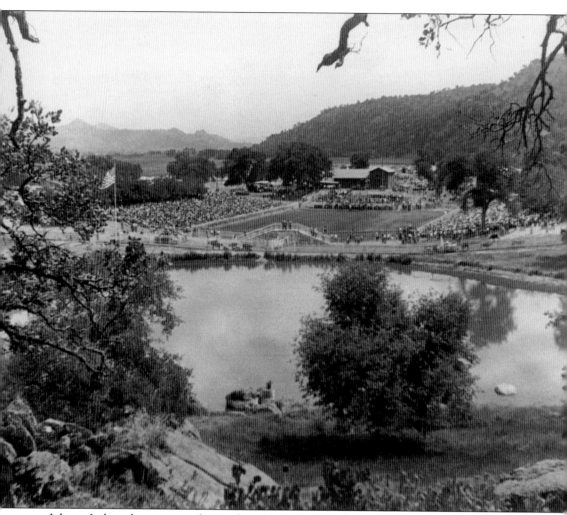

Johnny Jackson became a professional cowboy in 1947. He, his wife, June, and children, Craig and Sandy, moved to the 546-acre Sunny Slope ranch near Woodlake in 1957. It remained a working ranch with oranges, avocados, olives, and cattle. Jackson and his family, along with foreman Milt Baker and Lions Club members, hand built the rodeo arena into a natural ravine, making it a natural setting in which to accommodate 10,000 spectators. (Courtesy of Carl Scott.)

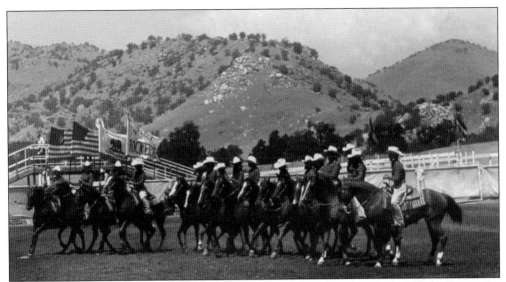

The Rockettes organized in 1955 from a Girl Scout troop. Girls ages 10 to 18 from all over the county, including Woodlake, participate in various parades and rodeo performances. Rockettes compare their drills to square dancing on horses, in which a team of 16 girls performs a routine set to music. Rockettes are judged on speed, spacing, timing, degree of difficulty, attractiveness, and flag carriage. (Courtesy of Lisa Kilburn.)

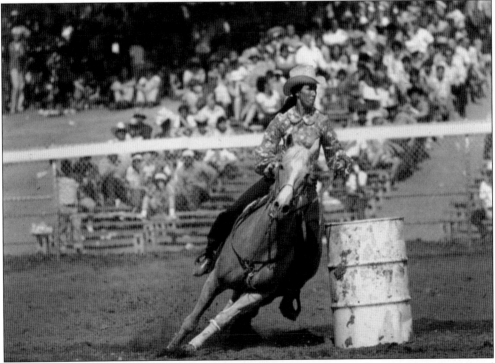

This 1972 barrel racer enters the arena full speed ahead, starts the cloverleaf pattern around three barrels, then sprints out of the area. The rider can touch or move the barrels but receives a five-second penalty for each overturned barrel. Traditional cowboy dress includes a cowboy hat, cowboy boots, and jeans with a belt and trophy buckle. (Courtesy of Lisa Kilburn.)

In the most dangerous event, riders had to stay on a twisting Brahma bull for eight seconds to qualify. Brahma bulls have the quickest action for any animal their size. While riding, cowboys may only hold on with one hand to a loose rope around the bull's shoulders. More importantly, the contestant has to dismount without getting trampled. (Courtesy of Lisa Kilburn.)

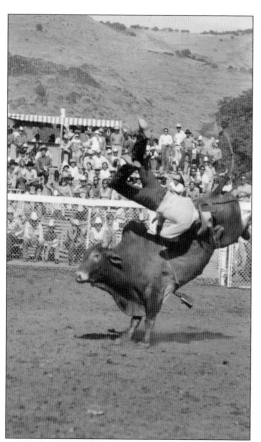

During the calf-roping contest, the calf enters and crosses a line before the horse and rider can break the barrier. Once the riders rope the calf, they jump from the horse and throw the animal by hand, remove "piggin' string" from their mouths, and tie three legs together. (Courtesy of Lisa Kilburn.)

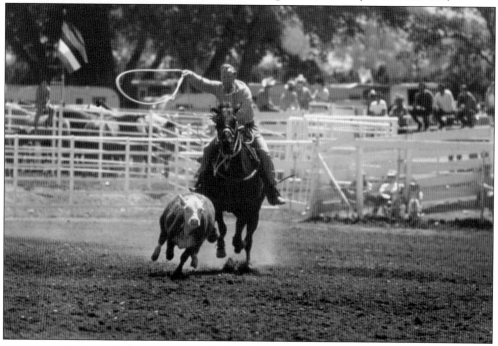

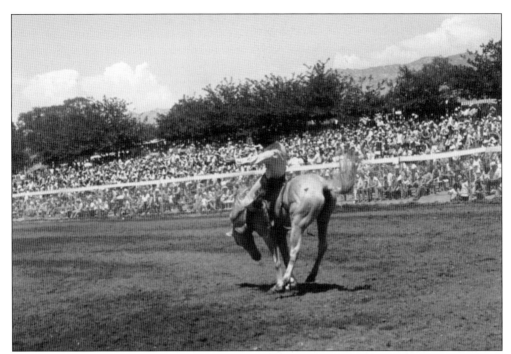

Pictured in 1972, two bronc-riding events, one with and one without a saddle, required the rider to spur the bronc and stay on board for 8 to 10 seconds, depending on the event. To make it tougher, the rider has to spur the horse's shoulders for the duration. The horse only has one goal—twist and turn to get rid of the irritating rider. (Both, courtesy of Lisa Kilburn.)

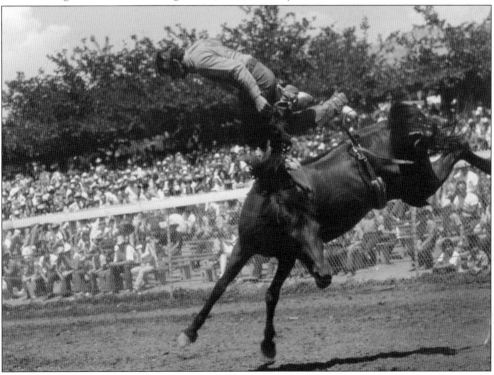

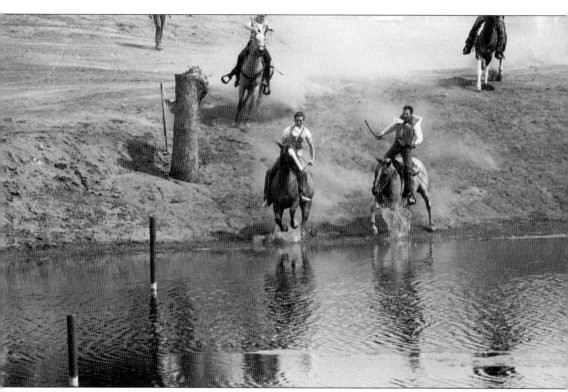

Cowboys anticipated the horseback suicide race in the early rodeo days. After a few mishaps, the event disappeared. New rules and prequalification changed the inevitable to possible, and the race returned. Contestants navigate a difficult course then return via the lake north of the arena. Riders inside the arena join them to finish the exciting race. This 1970s photograph is rumored to include Craig Jackson. (Courtesy of Lisa Kilburn.)

BIBLIOGRAPHY

Hamm, Katherine. *Tulare County Schools: One Hundred Years*. Visalia, CA: Sigma Chapter Delta Kappa Gamma and Tulare County Office of Education, 1961.

Kauke, Phillips C. *The Visalia Electric Railroad: Southern Pacific's Orange Grove Route*. Berkeley and Winton, CA: Signature Press, 2003.

Kirkman, Eva Pogue. *The Blair-Moffett Families: A History and Genealogy Between the Years 1600 and 1942, Additional Data Compiled and Arranged by Martha Brown Campbell from 1943 to 1976*. Visalia, CA: Josten's Publishing Company, 1977.

Pogue, Grace. *The Swift Seasons*. Hollywood, CA: Cloister Press, 1957.

———. *Within the Magic Circle: a Story of Woodlake Valley 1853–1943*. Visalia, CA: Visalia Times Delta. Second printing, 1971.

Tilchen, Mark. *Floods of the Kaweah*. Three Rivers, CA: Sequoia National History Association, 2009.

DISCOVER THOUSANDS OF LOCAL HISTORY BOOKS
FEATURING MILLIONS OF VINTAGE IMAGES

Arcadia Publishing, the leading local history publisher in the United States, is committed to making history accessible and meaningful through publishing books that celebrate and preserve the heritage of America's people and places.

Find more books like this at
www.arcadiapublishing.com

Search for your hometown history, your old stomping grounds, and even your favorite sports team.

Consistent with our mission to preserve history on a local level, this book was printed in South Carolina on American-made paper and manufactured entirely in the United States. Products carrying the accredited Forest Stewardship Council (FSC) label are printed on 100 percent FSC-certified paper.

MADE IN THE
USA